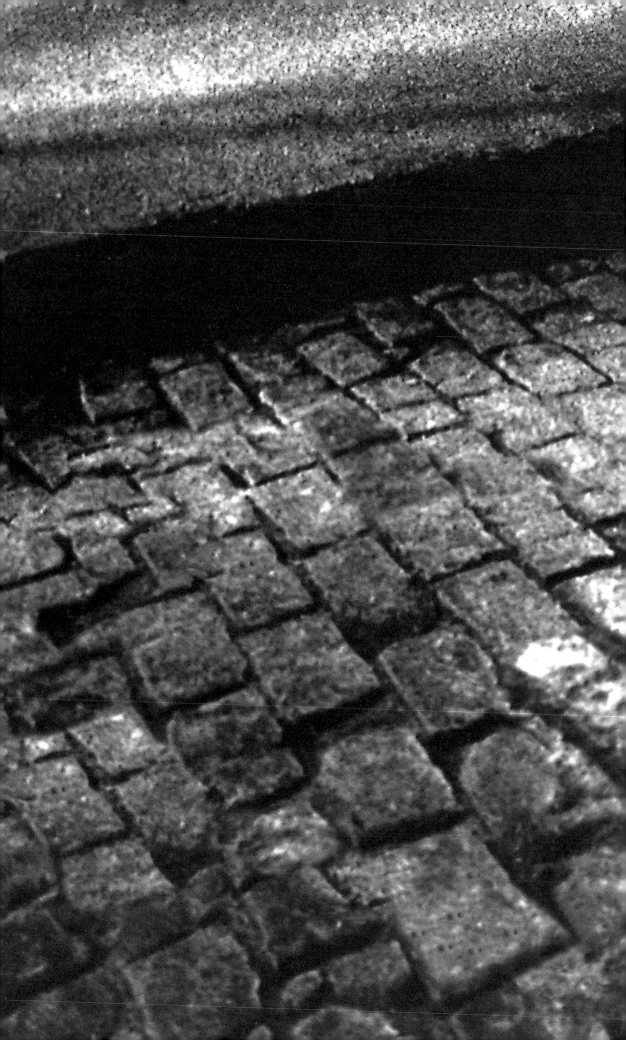

In the beginning there is the hearth, the ancestral fire, and you are a native of the flames. You belong there and therefore it belongs to you. Then comes exile, the break, the destitution, the initiation, the maiming, which—I think—gives access to a deeper sight, provides a path into consciousness through the mimicry of thinking yourself part of your host environment. . . . You learn, if you're lucky, the chameleon art of adaptation. . . . Henceforth you are at home nowhere, and by that token everywhere. . . .

You are engaged with an elsewhere that cannot be reached: Isn't that the defining characteristic of exile?

. . . The experiences and products of exile could be a dissolvent of border consciousness. It could be a way of reconnoitering, shifting, and extending the limits. . . . In your place of exile you would have introduced a dissonance, a feeling of the texture of awareness. . . . Exile teaches you about individual fate with universal implications, because it is eternal and has always been with us.

—*Breyten Breytenbach*

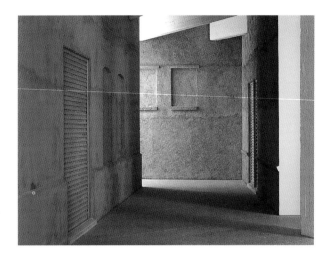

Life is itself exile, and its inevitability does not lessen our grief or alter the fact. It is a blow from which only death will recover us. . . .

So what is sent away when we are forced out of our homeland? Words. It is to get rid of our words that we are gotten rid of, since speech is not a piece of property which can be confiscated, bought or sold, and therefore left behind on the lot like a car you have traded, but is the center of the self itself. The excruciation of exile lies in this: that although the body is being sent into the world . . . the soul is being cast into a cell of the self where it may mark the days with scratches on the wall called writing, but where it will lose all companions, and survive alone. . . .

"Alienation" pretty well describes the condition of heart and mind which constitutes the inner content of actual, of effective, exile. . . .

Reality and memory were out of tune then, and now they are again.

—William H. Gass

Juan Muñoz

Text by Lynne Cooke

Dia Center for the Arts

New York

1999

Borders and barriers, which enclose us within the safety of familiar territory, can also become prisons, and are often defended beyond reason or necessity. Exiles cross borders, break barriers of thought and experience. . . .

Exile is never the state of being satisfied, placid, or secure. Exile, in the words of Wallace Stevens, is a "mind of winter" in which the pathos of summer and autumn as much as the potential of spring are nearby but unobtainable. . . . Exile is life led outside habitual order. It is nomadic, decentered, contrapuntal.

—*Edward Said*

Acknowledgments

This book celebrates two related installation projects by Juan Muñoz commissioned by Dia Center for the Arts, *A Place Called Abroad*, created at Dia and shown from September 26, 1996, through June 29, 1997, and *Streetwise*, created at Site Santa Fe and shown from June 6 through August 2, 1998.

Exhibitions at Dia often take the form of site-specific installations, as artists react directly to the physical or sociocultural character of the site. Juan Muñoz took this ambitious approach when responding to curator Lynne Cooke's invitation to create an exhibition. In both the galleries at Dia and the former brewery that was his site in Santa Fe, Muñoz preempted the existing architecture by diagonally cutting through the walls, constructing a shuttered and gated street, off of which were enigmatic spaces inhabited by remote and distracted, yet memorable, cast-resin figures. In traveling down the street and into the spaces, the exhibitions' visitors confronted the figures, intently engaged in their private exchanges. The disjointed, spellbinding narratives sketched by these figures and spaces continue to haunt our imaginaries. We duly thank the artist for those compelling evocations.

Exhibitions of this scale require the hard work and dedication of a number of people: At Dia, acknowledgment must first go to Lynne Cooke, who recognized the promise of working with Juan Muñoz at Dia, and wrote a remarkable essay on the two installations for this book, providing an insightful critique on Muñoz's fascination with architecture. Jim Scheaufele, Gary Shakespeare, Noel Barry, and Dia's installation crew worked with the artist and Lynne to design and build the street and the sparse, graceful spaces. Filiep Tacq worked closely with Juan for months on the design of this book, conceptualizing a framework for documenting the installations, while Karen Kelly and Bettina Funcke devoted themselves to compiling and to developing its content.

Site Santa Fe consonantly shared Dia's enthusiasm for Juan's project. Without their collaborative spirit and generous support, this publication would not be possible. We especially extend our gratitude to Louis Grachos, Curator and Director, and Craig Anderson, Exhibition Administrator.

Finally, Dia would like to acknowledge the individuals and organizations who made Muñoz's exhibition and publication possible: the Lannan Foundation, the Burnett Foundation, Plácido Arango, Nancy and Dr. Robert C. Magoon, the National Endowment for the Arts, the Spanish Ministry of Culture, and the members of the Dia Art Council.

Michael Govan
Director

I can't live forever in a windy, unfurnished imagination; I have to make a comfortable habitation there, fill it with a few household things . . . I have to add a bottom to the language that I learned from the top . . .

I want to recreate, from the discrete particles of words, that wholeness of childhood language that had no words. . . .

Since I lack a voice of my own, the voices of others invade me as if I were a silent ventriloquist. They ricochet within me, carrying on conversations, lending me their modulations, intonations, rhythms. I do not yet possess them; they possess me. . . . Eventually, the voices enter me; by assuming them, I gradually make them mine. I am being remade, fragment by fragment, like a patchwork quilt.

—*Eva Hoffman*

Strange now to look at the photographs and images that make this book, and which try to show the sense of what it was I was trying to do. Walking amongst and between these images, I find no explanation for the journey I have taken.

While making the work here, I listened to the music of two composers — Alfred Schnittke and Alberto Iglesias. My wife Cristina filmed the dog in the street on the last pages — "For no reason," she said. I offer my thanks to all of them for honoring me with their attention, their own walks among and between things.

—Juan Muñoz

A Place Called Abroad

Dia Center for the Arts, New York

September 26, 1996

through June 29, 1997

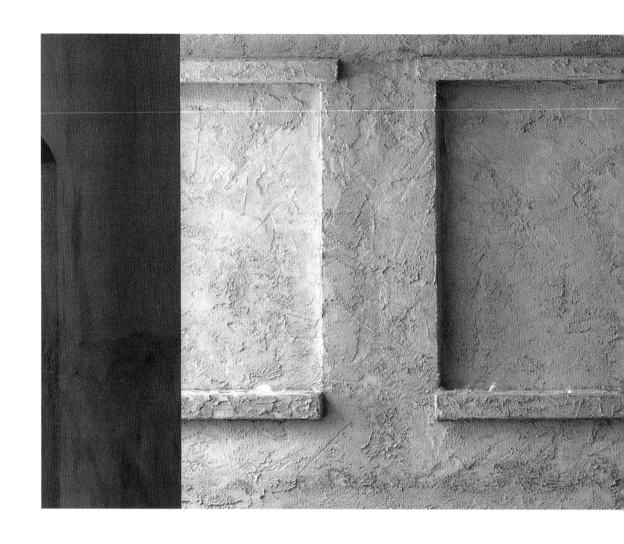

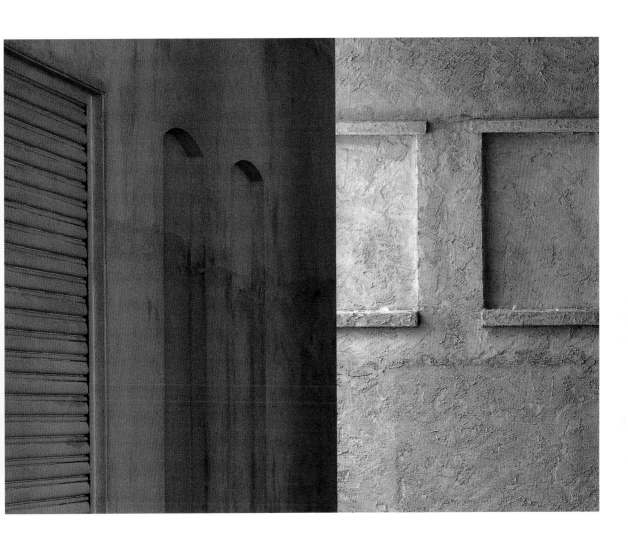

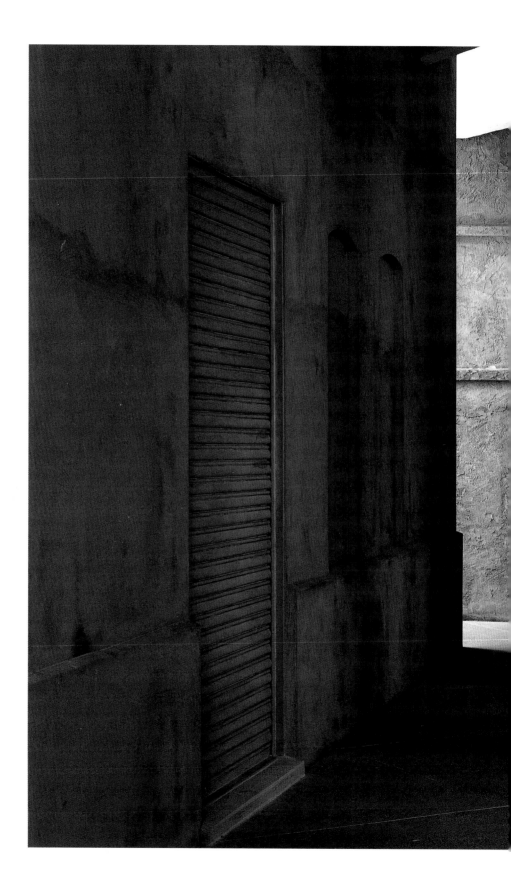

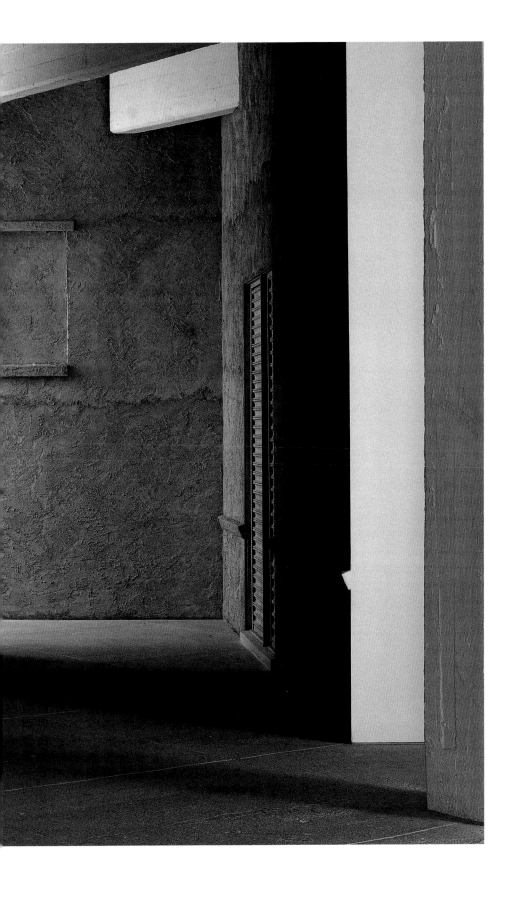

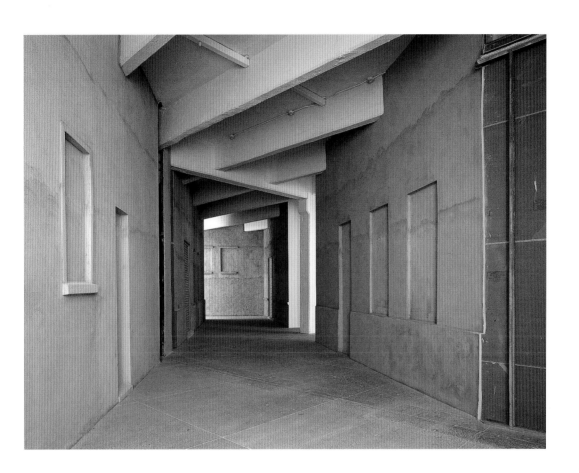

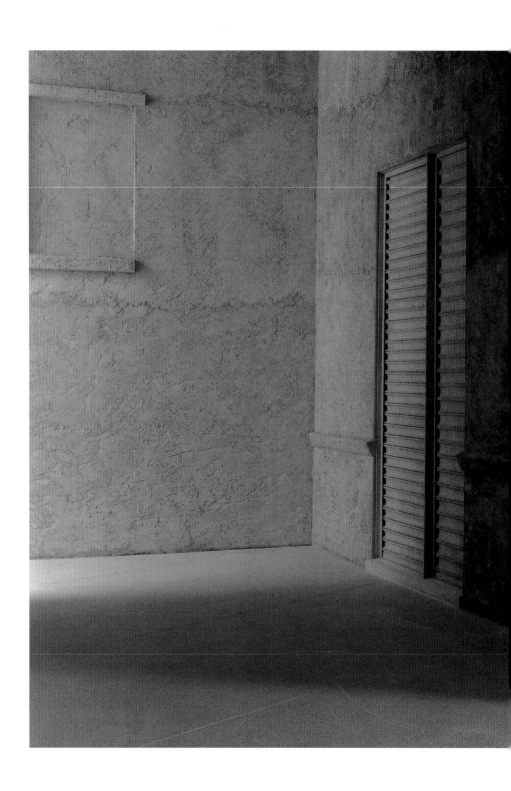

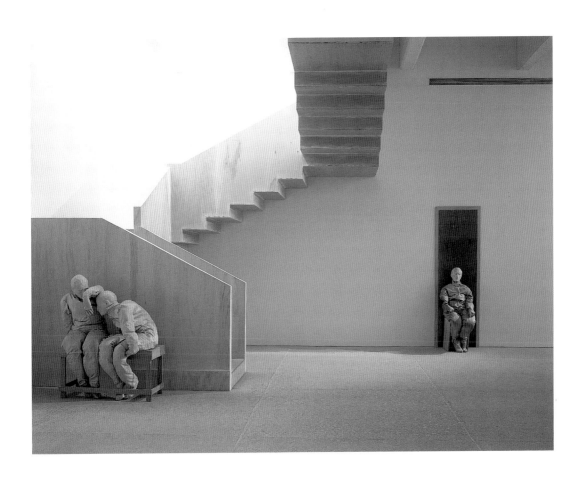

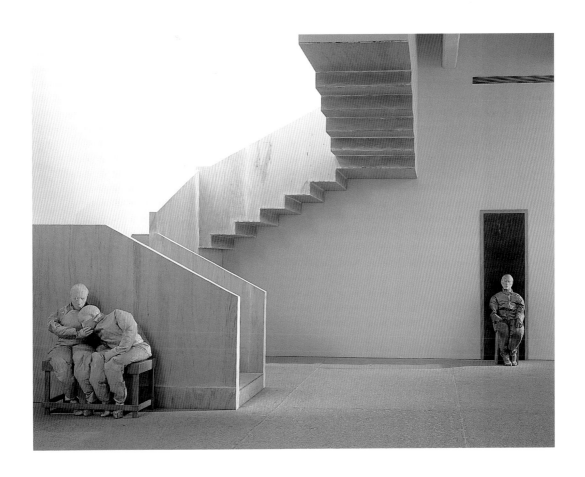

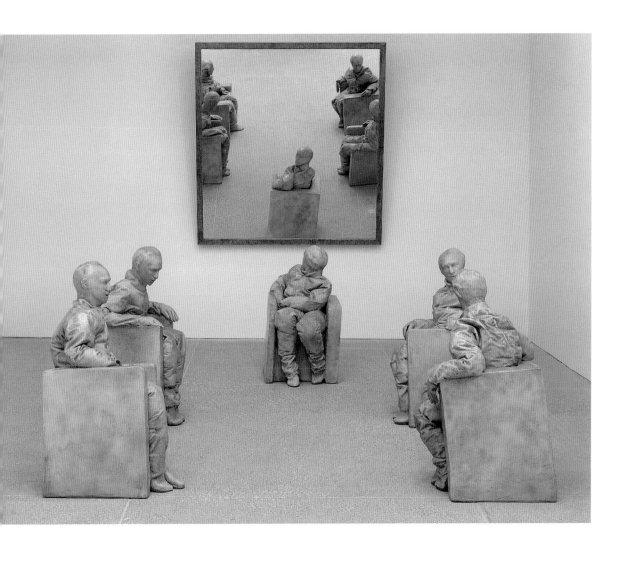

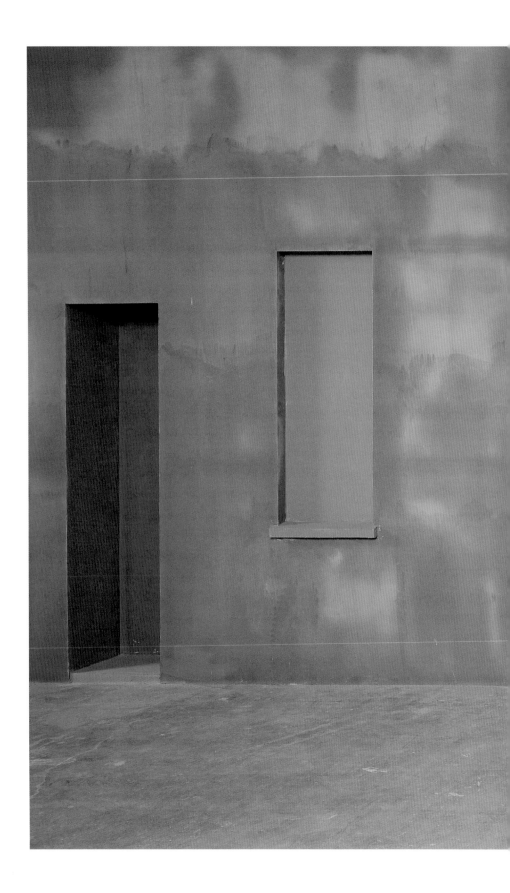

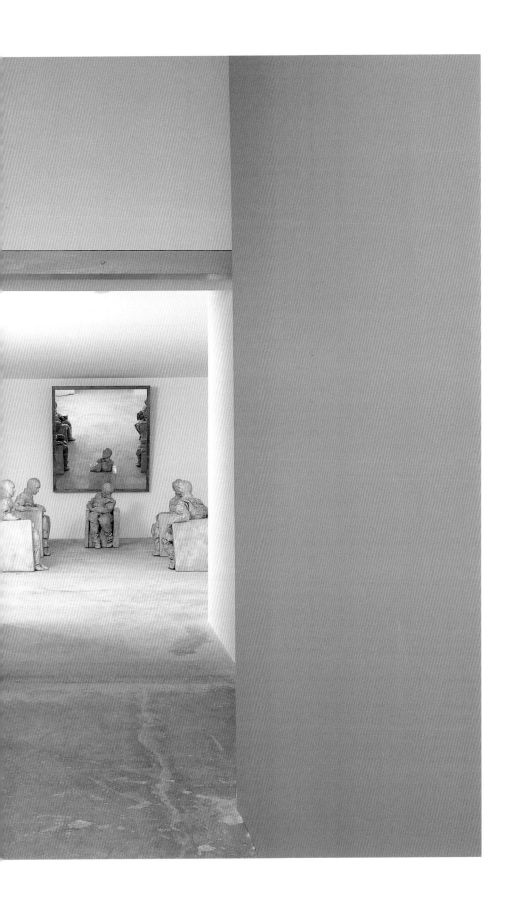

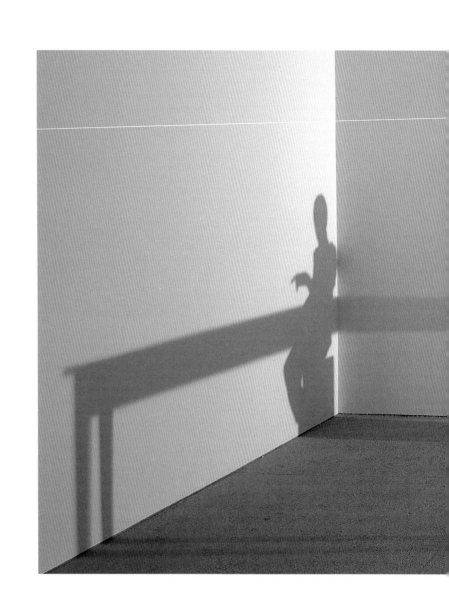

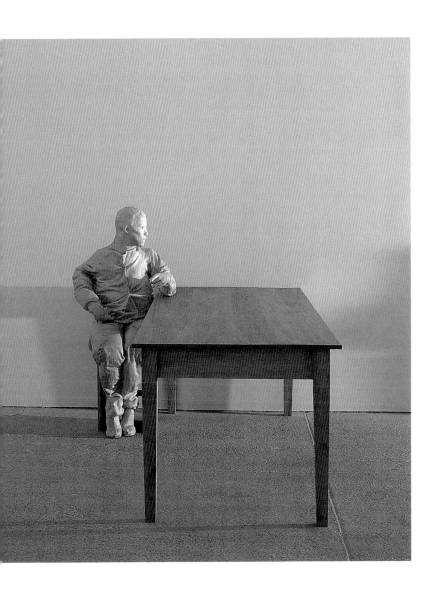

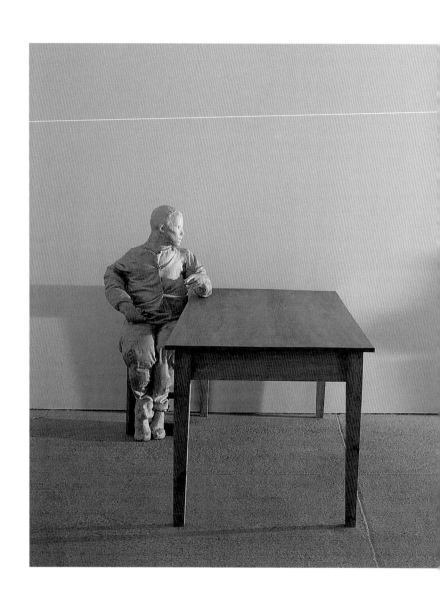

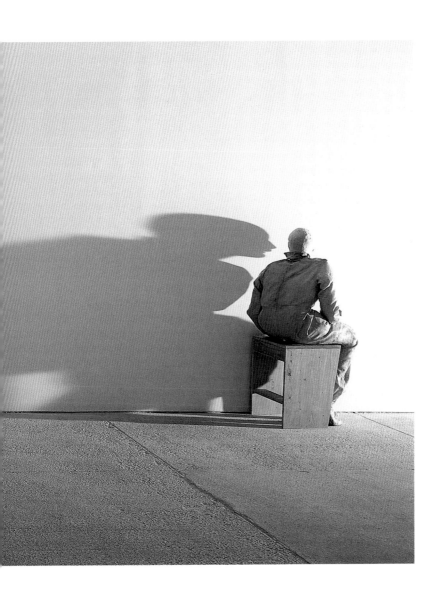

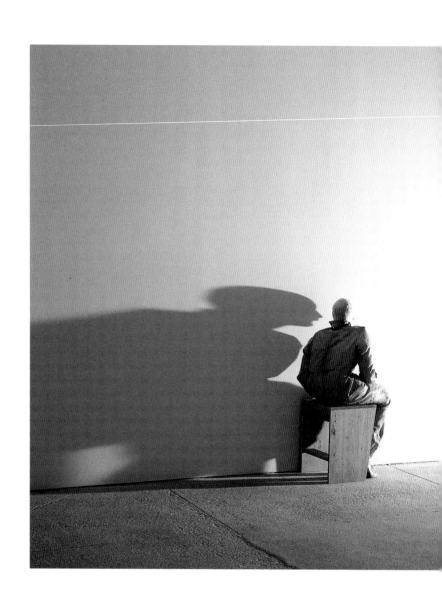

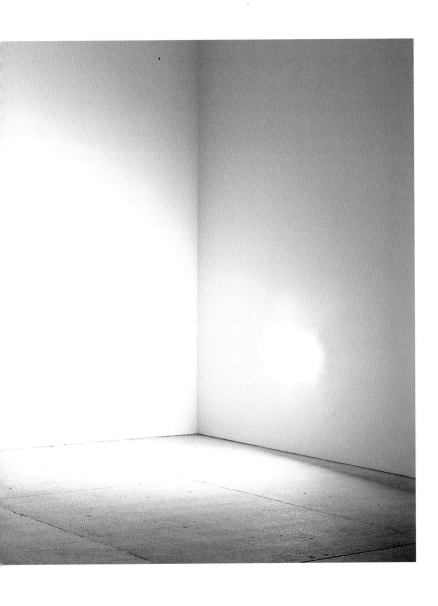

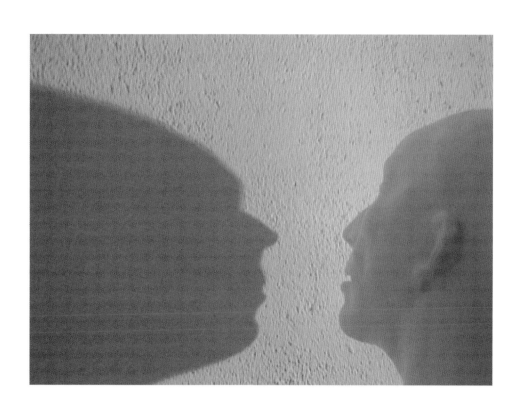

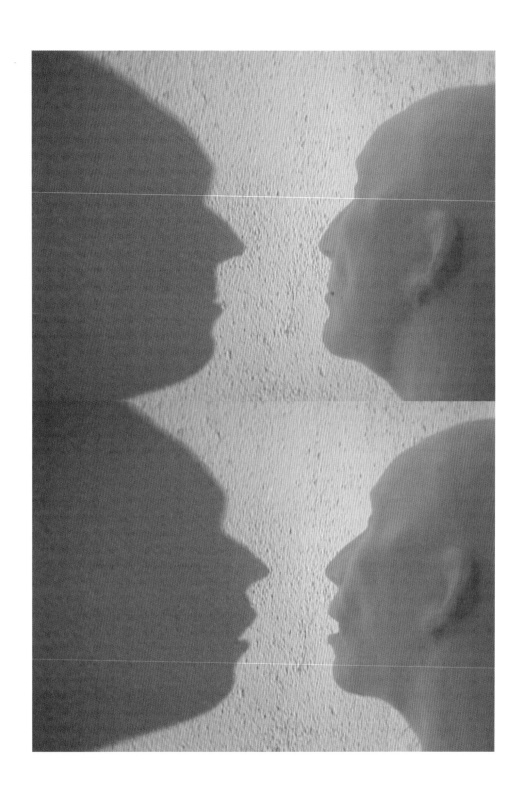

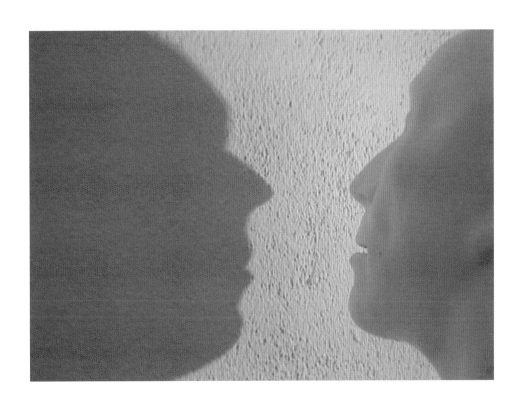

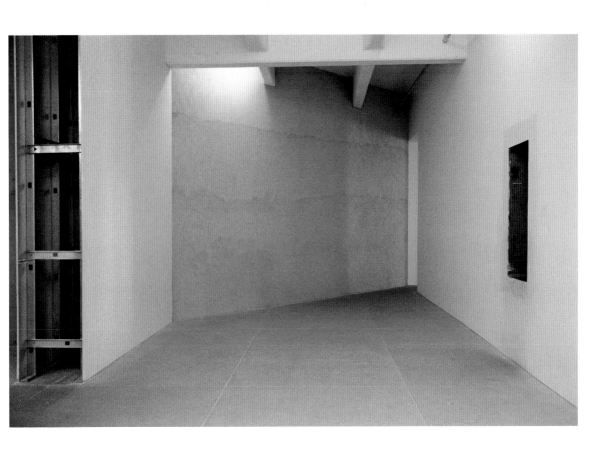

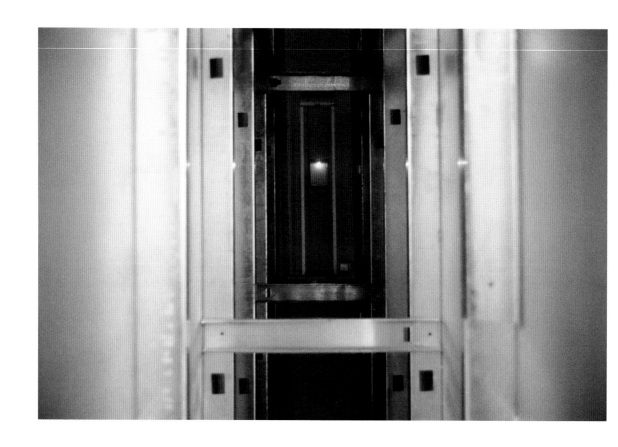

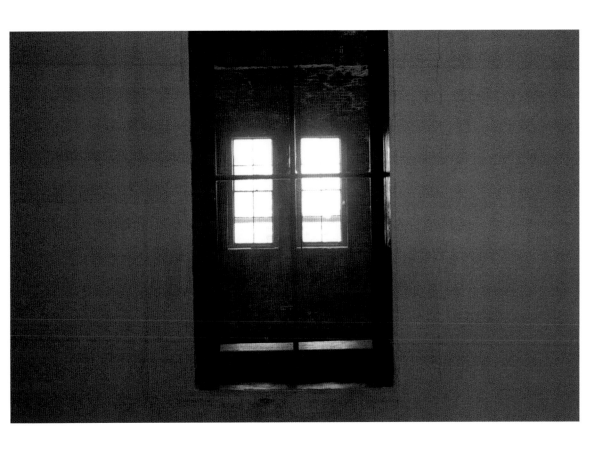

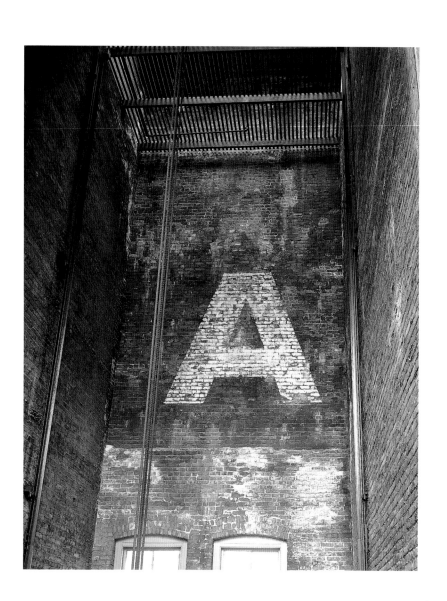

Juan Muñoz: Interpolations

Lynne Cooke

I build these works to explain to myself things that I cannot understand otherwise. The work should somehow remain enigmatic to me.

–Juan Muñoz

Certain ... genres (the realistic novel, for instance) and certain styles cannot, by definition, be practiced in exile. On the other hand, the condition of exile, by enforcing upon a writer several perspectives, favors other genres and styles, especially those that are related to a symbolic transposition of reality.

—*Czeslaw Milosz*

Arcades, even more than streets, were the ideal site for the urban itineraries of the flaneur, that passionate spectator who, in Baudelaire's celebrated characterization, immersed himself incognito in the flurry of the crowd, amidst the fugitive and the infinite: away from home, this loiterer felt himself everywhere at home. To Walter Benjamin, explicating and updating this thesis some half-century later, the figure of the flaneur again provided philosophical insight into the nature of modern subjectivity. For him, the perceptual mode that governs and informs this archetype's vision was akin to a dream-web where the most ancient occurrences are attached to those of today. Such a spatio-temporal juxtaposition and montage of images obscure modes of production so that the stroller's vision is reduced to a spectatorial reading of signs, depending on physiognomic impact, on consumption. Idling, cruising, or window shopping, the flaneur constructs a fantasmatic relationship to his environment.[1]

Abandoned, anonymous streets constitute a very different topos within the discourse of urban semiotics, yet one that is arguably part of the late twentieth century's inheritance from those now legendary arcades. The preferred habitat of the flaneur, city streets and arcades were the repository of an ideological attempt to reprivatize space, in which the individual's passive observation would prove adequate for a knowledge of social reality. By contrast, the modern urban milieu is informed by a loneliness that

embodies an existential condition, since the street today offers neither the luxury of the vita contemplativa to the solitary walker nor, as the public sphere par excellence, a place of communality, of dialogue. The contemporary descendent of the flaneur, the lone traveler, is once again in transit, but now he walks warily, estranged, in these empty, eerily silent, labyrinthine canyons. His vision, too, is skewed from that which is observed externally to that which is the product of an inner eye, from that which is seen with the organ of sight to that which is perceived internally by the imagination and intellect. From the fascinated voyeur that formed the subject of study for Baudelaire and Benjamin has metamorphosed a deracinated interloper—remote, disenfranchised, alienated. Isolation, disconnection, destabilization, anomie, and anxiety are his customary states of mind. Familiar and ubiquitous, this protagonist has peopled the work of diverse writers across the modernist era, from T. S. Eliot to Fernando Pessoa, from the authors of detective novels to the screenwriters of film noir.

Bathed in the somnambulistic half-light of a gloaming day and, alternatively, suffused by a tenebrous nocturnal pall, the deserted street was the subject of two large-scale installations that the Spanish artist Juan Muñoz created, first in New York City in 1996, then subsequently in Santa Fe in 1998. The street for Muñoz runs parallel to his hypothetical Posa, an archetypal house created by a fictional Peruvian tribe that forms the subject of his enthralling, pseudo-ethnographic tale published in 1989, as much monuments as urban artifacts, as much emblematic dwellings as conduits for the perpetually peripatetic.[2] His most complex and layered works to date, these twin mise en scènes, *A Place Called Abroad* and *Streetwise*, can be read as the culmination of an enduring dual focus: a longstanding preoccupation with architecture as a psychological locus and a symbolic sign system rather than a functionalist discourse; and a more recent probing of the image of the double, the dark duplicate that fissures modern subjectivity, evincing and embodying otherness. Interwoven, these abiding tropes became the vehicles for a poetic exegesis, in which, in the artist's evocative phrase, one "gropes for [his] true center."[3]

4

Sequestered on a balcony or concealed behind shutters, the detached beholder perches aloft, a passive counterpart to the lone streetwalker, immured in his dislocated and uncertain wanderings. Surveying from a site of seclusion, covertly watching those who wander distractedly below, the occupant of the balcony exists in limbo, somewhere above the fray, his subject held at a distance, transformed into spectacle. The protagonist of E. T. A. Hoffmann's short story "The Cousin's Corner Window," a paralytic is the progenitor of more renowned contemporary denizens, such as Alfred Hitchcock's incapacitated hero in *Rear Window*: he, too, experiences the vista beyond as a kind of tableau vivant. Hoffmann's story anticipates the ways though not the social reasons in which alienation became a convention, and scopophilia the modus vivendi, in depictions of the contemporary streetscape.

Small, welded metal sculptures of balconies, attached to the columns of the gallery space, constituted the majority of the exhibits in Muñoz's first solo show, held in Madrid in 1984. Dysfunctional, deserted, these stark aeries confounded the status of the space, transforming the interior of the exhibition site into an exterior, akin to a plaza, thereby morphing the context from the closeted sanctum of the white cube to a hypothetical urban milieu, where the viewer's engagement is more distanced, more dispassionate, less immersive. Given that his balconies are always bereft of occupants, as if encountered the moment after their departure or just prior to their arrival, an instant too early or too late, as if absence were their perennial condition, Muñoz's world seems hypnagogically suspended, anticipatory, marooned in indecision. Its haunting elusiveness depends, equally, on its distance from the norm. By distorting or otherwise disabling these lean structures, the young artist infused his sculptures with a state of psychic dis-ease more reminiscent of that permeating the sociocultural space dissected in the art of certain peers, not least Robert Gober's contemporaneous series of cots and cribs, than that which fuels the erotically charged milieu inhabited by Goya's Majas or their offspring, the beguiling avatars of Manet's fictive world. In contrast to the seductive play of gazes that flirt, tease, and sport with the spectator in

those iconic renderings, Muñoz's deserted terraces leave the viewer only too aware of his or her isolation and disconnectedness. A place where watching and pacing intersect and overlap, they fulfill the artist's steadfast conviction that "You just have one material world to explain another material world and the gap in-between is the territory of meaning."[4]

Watchtowers and minarets likewise proved suggestive motifs with which to continue this preoccupation with a state of waiting, of removal and suspended engagement. Also included in Muñoz's debut show was one such, *If Only She Knew* (1984). Precariously balancing on long spindly legs, this frail tower offered its crowd, comprised, exceptionally in his œuvre, of a female surrounded by male cohorts, an elevated threshold from which to scan the farthest distances in what, ultimately, can only seem a melancholy endeavor.

Temporarily relinquishing the miniaturized scale that reinforced a distance both literal and psychological, Muñoz soon began to incorporate the actual site, utilizing the space of the gallery as a means to heighten the state of divorce and destabilization into which his viewers could be precipitated. *The Wasteland* (1987) was the first of a number of works to substitute a geometrically patterned tiled floor for whatever surface was normally present. Derived in part from related forms in Renaissance painting and in part from Baroque architecture (which Muñoz, a knowledgeable devotee, describes as "in perpetuum mobile"), this motif was, as is the practice of this highly cultured artist, put at the service of the notion—the state of mind—embodied in Eliot's seminal classic of twentieth-century literature. As though seasick, the visitor to the exhibition crossed this dizzying incongruously warping plane with difficulty, uncertain how to situate or ground him- or herself given its unpredictably restless flow, its infinite repetitiveness. Since these perspectival distortions advanced only to negate each other, any place where the visitor rested momentarily threatened to open up, as if to plunge him or her into a vertiginous abyss, nothingness. At the same time, since the relentlessly unvarying patterns gave the impression of constant change, the treacherous surface ensured

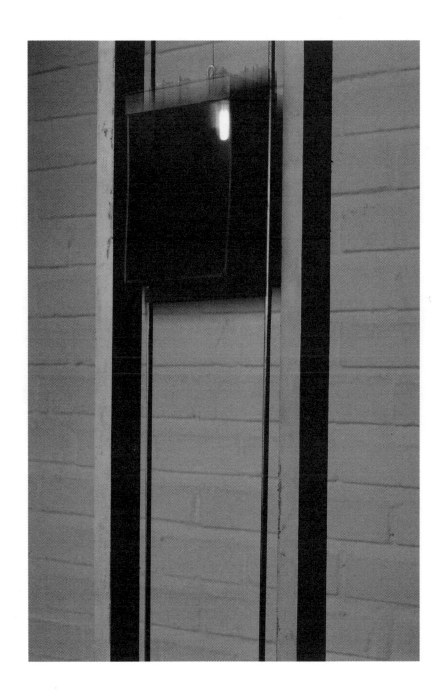

that the disoriented spectator remained perpetually in motion. On the far wall, a ventriloquist's dummy was propped on a narrow shelf, mute witness to every unsteady trajectory across the duplicitous terrain. A dumb receptor, a hollow effigy, such a cipher requires an external agent in order to be animated and to assume an identity: even then it remains a surrogate, dependent on a borrowed voice. And just as the mesmerizing domains of each of this group of works elude identification, so their nameless inhabitants resist individuation. Their personae suspended, they simply wait. Adjusted to the precise dimensions of each site, these deceptively simple installations actualize the viewer's relationship with a context in ways that ultimately remain ambiguous. For the place each demarcates is neither the gallery proper nor a fully illusionistic substitute, but something in-between. Neither strictly fact nor fiction, it refutes precise labeling. Through such carefully calibrated counterpointing, the artist, in his apt description, sets the stage for signification and readies its vehicles without giving anything away.

Muñoz once again shifted the scale, or at least the imaginary dimensions, of the site when, shortly after, at the end of the 1980s, he began a series of multifigure works known as Conversation Pieces. Slightly smaller than life-size and generic in character— more types than portraits—these mysterious players guard their anonymity by means of a generalized costuming that avoids all identifying marks of period or style. Long voluminous cloaks and coats mask their lower bodies, which terminate in hemispherical plinths. While fixed to a single spot, a precise location, they may take up a position, a viewpoint, facing in any direction, being obligated to none.[5] Dispersed in a large, otherwise empty gallery they incline and turn with balletic grace in a slow mime of attenuated discourse. Their silent narratives eddy and flow tantalizingly around the beholder, deaf to the content but not the allure of their silent cadences. Discreetly gesturing or exchanging furtive glances, clustering silently or lingering, mute and aloof, they engage at best only equivocally with their milieu. The distances between them can seem unbridgeable, and the terrain unbounded,

its spatial coordinates elusive: nonetheless, they are patently the denizens of piazzas, squares, or plazas. The anxious immobility, governed by a lack of purposiveness, that stirs these introverted idlers differs from that which traditionally motivated the passegiatta; ennui as much as any desire for sociality, irresolution as much as the pursuit of pleasure galvanize these passegiatta. Whereas social mobility and conviviality were the hallmarks of the eighteenth-century conversation piece, a stasis rife with restless indeterminacy prevails here. The larger groupings of related sculptures that followed, such as *Square* at the Crystal Palace in Madrid in 1996, expand upon this sense of isolation within the collective, of the unknowable or causeless separateness that undermines the appearance of camaraderie. Now fully modeled, as "Chinese" they sport simplified versions of Mao suits and Asian physiognomies. These works, once again, evoke only to thwart the potential for narrative, or at least for a meaningful set of relationships. Additionally, the more expressive identity deriving from their dress code, ethnic type, and unaccountable hilarity fails fundamentally to alter their status, the transitoriness and serendipity of their encounters, the pathos of a proximity shorn of intimacy. In contrast to that of most of Muñoz's previous protagonists—dwarves, dummies, mannequins, automata, prompters, and dumpy ballerinas, who operate under cover of aberration, marginality, disenfranchisement, and jest—the deportment of these casual bystanders now verges on the nondescript. Garbed in what the artist terms "the disguise of normality," their prevailing condition is, as Adrian Searle has so memorably described it, "at a tangent to the present . . . interminably stranded, always belated."[6] Self-absorbed in an unrequitable waiting in which all communication is finally precluded, they embody a solipsistic separateness, which has increasingly become Muñoz's obsessive subject.

Streetwalking through a topoanalysis, mapping a psychophysical terrain that is home to the peripatetic voyager who inevitably is in constant limbo, Muñoz imparted a new complexity to his dense lexicon of interwoven motifs in the installation at Dia in 1996. With its title, *A Place Called Abroad*, stenciled on the exterior wall leading

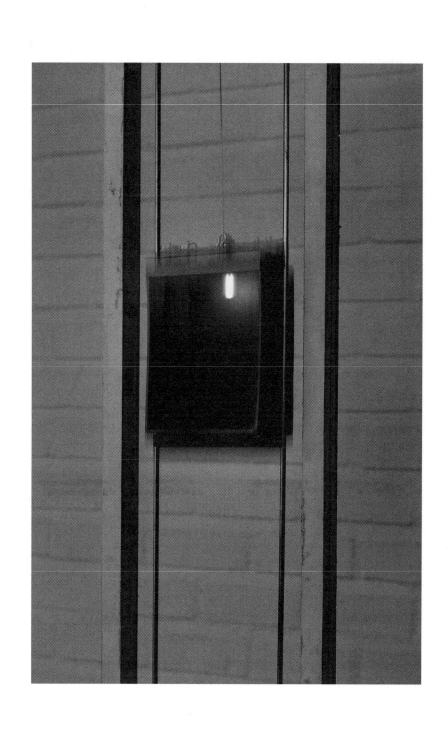

into the gallery, the installation signaled, from its threshold, that uncertainty and displacement lay at its core. For "Called Abroad" suggests that this might not be the real name of this realm, that it might be so considered for convenience, for lack of alternatives, or for any of a myriad of other unknown or unknowable reasons. Further compounding this uncertainty as to identity is the notion that an encompassing generic designator could be fixed to a localized site such as this: "abroad" of its very nature is elsewhere. Distant from his familiar, habitual places of residence, the epigone of a fictive milieu such as this is presumably a solitary nomad, an itinerant in a foreign country.

Approaching the gallery proper, the visitor, whose journey through the work will parallel without becoming cognate with the perspective of an estranged sojourner removed from his homeland, was funneled down a narrow corridor, then propelled suddenly around a corner into a long roadway, whose borders were lined with a succession of buildings, all of whose windows and doors were firmly shuttered closed. Rending this vista at several points were open seams exposing the studs and dry wall from which the tableau had been constructed, consequently, on the one hand, briefly dispelling the illusion, while, on the other, simultaneously making the audience keenly conscious of its complicity in this theatrical mise en scène.

As the visitor hesitantly entered the deeply shadowed streetscape, passages into other spaces unexpectedly opened up. The first two of these were oddly ambiguous. In one, a strangely truncated, triangular cul-de-sac eerily raked by a low, searing sidelight, two young men huddled on a bench, momentarily transfixed in some arcane but private ritual. In the larger of this pair of indeterminate sites, a related rite absorbed two similar figures, as anonymous and depersonalized as their companions in the adjacent space, while a third sat, as if on guard, in front of a blind embrasure, withdrawn, lost in some inner world. The staircase that separated this youth from the duo nearby was domestic in scale, yet the otherwise spare character of the containing space supplied few

clues as to its function, even whether it was an outdoor or an indoor site. Further confounding its role and identity, the steps offered no egress, being abruptly curtailed in a dead end. Limned with an abbreviated naturalism, these figures are most convincingly life-like, most vividly present, when espied in passing or askant. Given that under close scrutiny illusionism breaks down, a certain distance becomes a prerequisite for optimal impact. The essential physical removal has a psychological corollary: Muñoz's figures are always either self-absorbed or involved in some enigmatic interchange that renders them oblivious to all else. Never soliciting any engagement with the viewer, their impregnable self-preoccupation cathects their audience, thereby creating a relationship as unsettling as that generated between the architecture that shelters them and the discombobulated spectator.

Resuming the route, turning another corner, the visitor found him- or herself at a crossroads, literally, metaphorically, and metaphysically. At this point of suspension, of immobilized indecision, a kind of doubling and inverting of options and information intensified doubt as to how to proceed. Flanking the intersection to the right was a façade on which a partially erased fragment of a sign, the letter A—alpha, a beginning—was faintly visible. Through a domestically sized and detailed window on a facing wall, a similar A could be spotted on a tall brick wall some twenty feet away. The echoing shards of signage, plus the unexpected glimpse onto a building outside through an edificial aperture, momentarily masked the fact that Muñoz's window provided a view into the elevator shaft of the warehouse in which the exhibition galleries are located. Sly reference to the absent elevator was made by a small toylike variant implanted into the seam of the wall stud to the left, the other boundary marking the junction. With its dramatic reversal of scale and perspective, the tiny scarlet cabin, ceaselessly mounting and descending, became a poignant metaphor for a Sisyphean journey devoid of destiny or resolution. With no way forward, the visitor was forced into turning in one or the other direction, quitting this place of transit, from which digression seemed as likely as discovery of any "true" path.

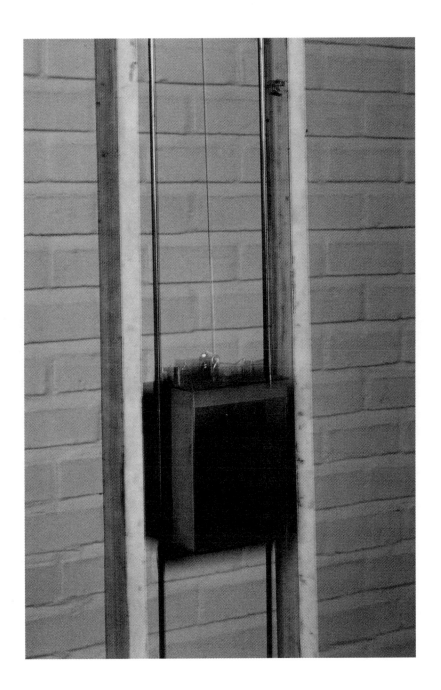

Choosing the right fork quickly led to a small room inhabited by a group of five seated figures, one of whom had seemingly fortuitously discovered its reflection in a mirror angled on the wall behind its back. His consternation at the evidence of a double, or other self, immediately conveyed itself to his companions, themselves near clones, or alters.[7] Venturing into the closely configured space, but long before reaching any of the seated protagonists, the viewer suddenly saw his or her own feet imaged in the same mirror. The abrupt and stark recognition that this insertion of the actual into the representational constituted not only an unwarranted intrusion, but an inevitably incomplete portrayal, given the tilt of the glass from the vertical generally halted the visitor. To proceed further seemed to involve penetrating an inviolable if invisible border and breaching a close-knit, self-contained psychic space.

Rebuffed, superfluous in the face of such intense self-disclosure, the visitor usually then retraced his or her steps in search of the alternative branch of the intersection. This option terminated in a situation that, at first, proved difficult to decipher. On the near side of a large room, a crouching figure sidled up against the far wall, lost in a silent monologue. The nature of this absorbing activity was disclosed initially by the huge, anamorphically distorted shadow he cast behind him, rather than by direct observation. So large that it seemed to elude control, even to escape its source, the hyperbolized shadow indexes a split personality, a rampant schizo. The tension between the vast size of this baleful specter, almost estranged from its source, and its averted, oblivious owner, cleaving to the architecture in his soundless litany, discouraged the visitor from approaching too closely; to do so would once again have meant violating what was clearly, if not literally, demarcated as personal space. Seated across a large, domestic table at a right angle to his companion, a second figure recoiled, transfixed not by the distended double, which was unreadable from his perspective, but by the sight of his cohort confessing to the wall. Instinctively, automatically, the audience kept a cautious distance from this overwrought agent, as from his partner. Since the vantage point required to read normally the anamorphically distorted image was

14

radically at odds with all else, it reinforced an awareness that this matrix could never cohere into a visual and, by analogy, psychic whole.[8] If introducing a disjunctive viewpoint thereby safeguarded the sanctity of the enigmatic mind space shared by these protagonists, it simultaneously identified the apparition as a figment of an alternative vision.

Here, as in the room at the other end of the crossroads, the self was once again revealed as a complex of images, representations, and doubles, a shifting nexus of fleeting projections. And here, as elsewhere in Muñoz's art, the audience was prevented from actively participating in the mise en scène, and was forced to acknowledge an insuperable separation from this charged domain of the uncanny, and to confront the estrangement, anxiety, divorce, and isolation that permeate it. Victor Stoichita has argued that the whole dialectic of Western representation has taught that frontality and the mirror constitute the symbolic form of the relationship between the self and the same, whereas the profile and the shadow comprise that between the self and the other. Muñoz, however, seems to equivocate in his response to both norms so that confrontation never quite takes place and opposition never completely stabilizes. In his installation the mirrored reflection is caught from behind, over the protagonist's shoulder, while the shadow is so obliquely aligned with the profile that their relationship is antipodal: in his vision, the one proves multiple, the same different.[9] How the self is envisaged and constructed thus becomes a conundrum, one that entails avoiding rather than engaging, recognizing loss rather than retrieval or discovery, and an act of splitting and multiplying rather than of unifying and cohering. Best defined as that which ought to have remained secret and hidden but instead has come to light, the uncanny according to Freud stems from the double, which, though a creation of an early mental stage, later becomes a thing of terror. For Jung, by contrast, the double was that primitive twin, the Shadow, one of those archetypes or complexes of experience that overwhelm one, like Fate. A phylogenetic memory—the encounter with the (dark) half of the personality—according to both these theorists, comes about of its

15

own accord, unbidden. For Muñoz too, it, potentially ever present, constantly resurges.

Crucial to each of his alternative scenarios were devices with long pedigrees in representations of the self: the mirror and the shadow. Both bear histories in which they have proved essential in constructing a reflexive identity, furnishing keys to an inner or other life, whether that of the alter ego, the double, the soul, or . . . Provoked by an insurgent revenant, the ricocheting glances among the group of five seated figures sets up a tight circuit in which the self seems to find itself at once confirmed and, simultaneously, trapped within its own inner compass, locked within its own echoing self-imaginings, attentive only to that which confirms, by echoing and reiterating.[10] This abstemious self-containment contrasts markedly with the indecisive, fluctuant nature of his sibling, whose inner being revealed in negative approximates that of a predator, a supernumerary. The rhetorical overreaction of the witness under-lines the sinister character of the ballooning shadow hovering, magnifying, and demonizing through its skewed distortion. This disturbingly ominous black form, stretching across the wall like a huge smear, insinuates a diabolical character, externalizing the deeper self. Counterposed is the silent speaker who surrounds and encloses himself within an auditory world suffused with a voice of his own conjuring, in a concentrated effort to create a self-sustaining consolatory matrix that can neutralize his dark foe. Ineluctably riven, this haunting figure offers an indelible image of the solitary individual perpetually subject to the agon of narcissis-tic self-fashioning.[11]

On leaving, the visitor has no choice but to retrace his or her steps, resuming the journey in reverse, a fitting symbol for the circuitous navigation of the psyche that lies at the heart of Muñoz's project. Once the street has revealed itself as a deterritorialized even more than deserted zone, the lighting appears to grow more cloying and crepuscular, and the distinction between interior and exterior, between, that is, an internal world and an external one, becomes correspondingly confused, more blurred, less certain.

Benjamin memorably described the mutating topos of the street, in an account that Susan Buck-Morss contends must surely be autobiographical:

> An intoxication comes over the person who trudges through the streets for a long time and without a goal. The going wins a growing power with each step. Ever narrower grow the seductions of the stores, the bistros, the smiling women; ever more irresistible the magnetism of the next street-corner, a distant mass of foliage, a street name. Then comes the hunger. He desires to know nothing of the hundred possibilities to distill it. Like an ascetic animal he strides through unknown quarters, until finally in his room, which, strange to him lets him in coldly, he collapses in deepest exhaustion.[12]

This room is, however, no longer a haven, since it may be read as interchangeable with the street, as, for example, in the writings of Søren Kierkegaard, whose philosophical flaneur goes for a walk without ever leaving his chamber. Such theoretical sources for the concept of urban alienation frame the intellectual heritage that Muñoz embraces but never seeks to illustrate. Elliptical, distilled, his work has more in common with the works of certain lapidary twentieth-century poets and novelists than it does with the (inherently garrulous) theater, with which it is frequently aligned.[13] In essays meditating on the nature and function of poetry, John Berger, a writer who collaborated with Muñoz on several occasions, articulates a position that has many affinities with the aesthetic of the younger man: "The poet places language beyond the reach of time; or, more accurately, the poet approaches language as if it were a place, an assembly point, where time has no finality, where time itself is encompassed and contained," Berger writes.[14] Eschewing the specifics of the historical, of a spatio-temporal locus, territory becomes unfixed: though anonymous it never relinquishes its concreteness, though outside temporality, it never forfeits its presentness. "For me," Muñoz affirms, "the best sculptures seem to linger in time. Their future is forever postponed and they have a certain indifference to time."[15] Similarly, for him as for Berger, space, despite its duplicity, and place, despite its unfixedness, are equally fundamental to this contemporary exilic

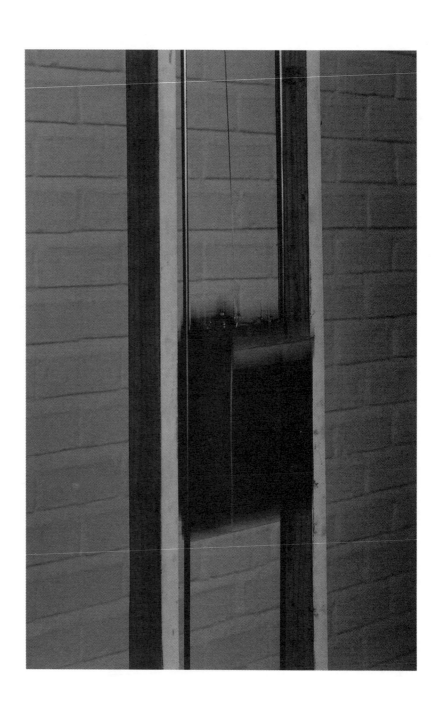

mind-set, for both, the primary subject of their art. "Today, as soon as very early childhood is over, the house can never again be home, as it was in other epochs," Berger argues. "This century, for all its wealth and communications systems, is the century of banishment. . . . Emigration does not only involve leaving behind . . . but also, undoing the very meaning of the world and—at its most extreme—abandoning oneself to the unreal which is the absurd. . . . To emigrate is always to dismantle the center of the world, and so move into a lost, disoriented one of fragments."[16] Berger's abiding preoccupation with a state of exile is eloquently echoed in Muñoz's beloved paradigm of the intersection or junction, a primary place marker in his mindscape. "Crossroad. Place of transit. Space inscribed in its own exile. House/Interval. Place that is negation of movement and at the same time generator of pathways."[17]

The streets were dark with something more than night.
—*Raymond Chandler*

Returning a year later to the subject of the streetscape, Muñoz dramatically changed both tone and trope, transforming the uncanny into something more gothic, and replacing the vestigial melancholy with a more sardonic and corrosive humor. In New York, he derived the details and forms of his street in large part from buildings in the vicinity of the converted warehouse that is the site of Dia's exhibition facility. All surfaces and apertures—windows, doors, and walls—were coated with a dark gray plaster that unified and consolidated the fabricated milieu. The layout from the previous exhibition presented in this gallery determined the dimensions, proportions, and configurations of the spaces leading off this central spine. Muñoz accepted as a given, as part of the site's history, this preexisting footprint, using it as a filter through which to define his own layout. This former configuration also conditioned the breaks in the walls, the fractures where their interiors were exposed; the illusion of an urban environment was consequently temporarily dispelled. Other aspects of the space were also exploited, not least the freight elevator shaft.

When devising a plan for Santa Fe, Muñoz faced a site and a structure quite different in character. A former brewery, this cavernous space lacked many of the features in Dia's building, though in compensation it offered others equally idiosyncratic. From the artist's perspective, the principal of these stemmed from the possibility of

cutting through the fabric of the building to create a window that opened directly onto a train track some fifteen feet away, along which freight trains frequently passed. While Muñoz once more inserted the feigned street diagonally across the building, he now used the window carved into the façade as a pivot, as the fulcrum for a countermovement that eventually spilled out into a piazza, before narrowing again into a junction, which the viewer confronted once more with two equally weighted options.

In Santa Fe, Muñoz's street was lit primarily by the raking light spilling from outdoors, which lured the visitor quickly past a series of shuttered doorways, porticoes, and windows. However, a small room opened unexpectedly to the left, revealing that same group of five seated figures with the mirror first seen in New York. For those who had witnessed the earlier installation, memories were evoked only to be confounded, for thereafter echoes of the previous experience were always slightly distorted, wrenched off-key by the increasingly melodramatic timbre of the monochrome mise en scène. Turning the corner after a tantalizing view of the panorama beyond which, invoking the time-honored vernacular of rail-hopping, signaled freedom and escape, the spectator ventured in the opposite direction along a narrower, more gloomy pathway. Not only did the false perspective of its receding facades rapidly prove disorienting, but the route itself became partially blocked by a small overturned car. Barely visible in the somber half-light, the vehicle soon proved to be no more than a hollow shell, its interior mysteriously occupied by a labyrinthine series of staircases that, Piranesi-like, twisted and spiraled down into invisible depths. Beautifully crafted, this miniature world reprised the unfathomable domain that was the subject of this installation as a whole: metaphorically, its role paralleled that played by the baby elevator concealed in the wall in Manhattan.

After passing an almost invisible balcony perched high at the corner, the visitor was catapulted onto a broad open square in which a number of figures sat on bleachers, their backs turned. The unaccountable mirth that linked them unleashed a deeply unsettling

mood, compounded by the visitor's arresting glimpse of their doubles in a mirror, which was set into the upper half of a pair of broad metal doors at the opposite side of the piazza. Momentarily not recognizing that this was in fact only a specular space—disconcerted by the impression that an identical and equally strange coterie occupied the other half of this stark plaza—the spectator then detected his or her own reflected passage through that barren site, while at the same time growing hyperconscious of the absolute indifference of the phalanx of animated figures, whose high humor soon felt barbed and derisory—more mocking than mirthful, more exclusionary than communal.

Precluded from any exchange yet apparently the cause of a bonding amusement, Muñoz's audience had to admit that it was again an interloper. Otiose and abashed, it exited only to find itself hesitating at another crossroads. As before, this conjunction of intersecting paths inscribed a point of exile, a negation of movement, which simultaneously generated new options. Each option appeared equally inviting. As before, neither proved more illuminating or consequential. In the left of the pair of dark rooms accessed from this fork, the far wall was filled with a giant black-and-white photograph, shot at night, of an apartment block whose façade was partially concealed by a fire escape. Two life-size male figures, their faces again averted, conferred mysteriously, casting foreboding shadows on a nearby wall. The dramatic low light, the harsh tonal contrasts, the bleak backdrop of the seedy architecture, together with the air of furtive collusion in an otherwise deserted milieu, created an overwhelming sense of unidentifiable menace, even of macabre threat. The tone and aesthetics were canonical film noir.[18] Like the silent buildings resolutely closed to entreaty, like the unattainable world beyond the framed window, the abandoned car, victim of a violent flight, seemed, in retrospect, also to derive from this cinematic paradigm.[19]

The alternative path leading to the neighboring space, a mirror image of the first, reinforced this allusion to American cinema of the 1940s. A vast mural covered the far wall: again it depicted a

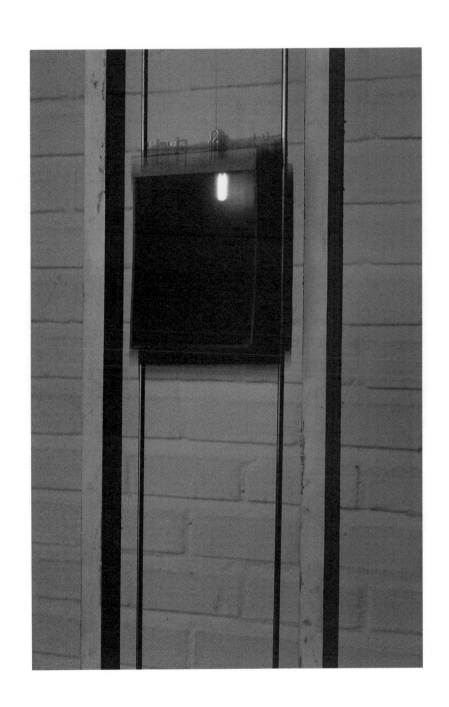

nocturnal scene, now the glistening surface of a cobblestoned road on which the front section of a parked car was seen obliquely from above. The gigantic closeup of part of the stationary sedan generated a claustrophobia, the perfect counterpoint to the agoraphobia, similarly infused with a glimmer of fear, galvanized in the adjacent room. In both tableaux, certain standardized ploys from film noir were melodramatically employed to demonize the cityscape. This time, a lone figure, arms outstretched as if frozen in terror, confronted himself in a large round mirror. Transfixed by his self-image, this histrionic gesturer wore a sardonic disconcerted grin, as if to placate if not dissipate his welling fears. As before, the chiaroscuro lighting was dramatic, not to say theatrical. A single, strong lamp, reminiscent of a car's headlight, placed on the ground to his rear provided the only source of illumination. Frankly artificial and contrived, it disclosed how these expressionistic effects were created without, however, dispelling their affect.[20] As a result, notwithstanding the overt staginess of the means of realization, that well-rehearsed aura of grim and baffled fatality integral to film noir prevailed. Yet, oscillating between the portentous and hyperbolic, the lugubrious and the comically clichéd, this unnerved assailant reiterated the doubling and inversion of its conspirators in the adjacent room. An enduring axiom in the imaginary for the phantom self, the reflection, like the shadow, once again invokes subterranean phobias. Now filtered through the guise of the grotesque, these devises have become infected with a subversive black humor, which strives to defuse or mock. Paranoiac overstatement marks this reprise of twentieth-century cultural pessimism and apocalyptic malaise. If the temper of the present times is once again jittery and skittish, anxious and dislocated, as it was in the immediate postwar eras of the 1920s and again in the late 1940s, for Muñoz, as evidenced in these culminating sections of *Streetwise*, an irrepressible element of farce must infiltrate any recurrence. The absurd is thus as much part of the contemporary mindscape as were Manichean terrors in previous eras.

A socially grounded vision informed both Expressionist cinema and film noir. Muñoz, by contrast, seeks to explore a condition more metaphysical in its determinations, one that is shaped above all by a permanent state of inner exile, homelessness, transition, solitariness, and solipsism. Architecture and urbanism, those preeminent arts of spatial definition, offer a suggestive lexicon for evoking displacement, nomadism, and estrangement as the foundation of the modern condition. "Vagabond environments [that] refuse the commonplaces of hearth and home in favor of the uncertainties of no-man's land," Anthony Vidler contends, have become "the close counterparts to the otherness at the core of the modern self." Through splitting and duplication, this schismatic self leads a kind of elementary dual existence in which the other—figural or architectural—finally becomes an inescapable companion and confidant in and of itself.[21]

Manifest in this installation by the grotesque, as in the former by the uncanny, fear serves as the primary instrument to explore this condition. "The defining flavor of the modern sensibility," fear, Marina Warner asserts, burgeoned in "the perverse and ironical fantasies of fairy tale at the end of the seventeenth century where dread was cultivated as an aesthetic thrill," only to find its twentieth-century counterparts in the uncanny and the absurd.[22] Today's millennial taste for the grotesque as a style, a mood, and a sensibility assumes, in Muñoz's art, a provocative defiance, a gothic exaggeration, and a nightmarish hyperbole that owe far more to the phantasmagorias of inner imaginings than to the horrors of the phenomenal world. That is, Muñoz's ciphers spring from the realm of the grotesque—from the order of representation—rather than emanating from the monstrous—the order of nature. Conjured by the troubled mind, such abnormalities and disfigurements bespeak a psychic condition, as common a reflex of the hyperconscious brain as are dreams, reverie, fantasy, phantasm, hypnagogic hallucination, trance, vision, rapture, and nightmare. Yet, as Muñoz's choice of title for this refrain intimates, his stance is

25

increasingly riddled with a dissident self-mockery, one that is nonetheless replete with affect. More than a salutary reminder that the insurgent subgenres of the sublime—the grotesque, the caricature, the fairy story, the melodrama, and the horror story—ultimately undermined its overarching premises and transcendent ambitions, it confirms their centrality in a manifestly transitional time.

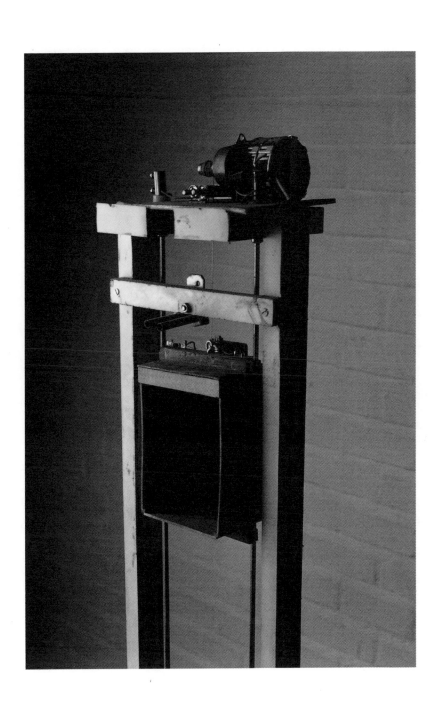

Notes

1. The identity of this inhabitant is always presumed to be male, for this public space was traditionally only available to men. Those women who became streetwalkers risked both danger and ostracism, being inevitably considered prostitutes. For Muñoz, such transgressive sites have not to date become spaces of sexual desire.

2. See *Juan Muñoz: Segment* (Chicago: The Renaissance Society at the University of Chicago, 1990).

3. Ibid., p. 21.

4. Juan Muñoz, a conversation with James Lingwood, September 1996, in *Juan Muñoz: Monologues and Dialogues* (Zürich: Musuem für Gegenwartskunst, 1997), p. 159.

5. In that they invoke issues relating to balance and support, these figures of rotund bases have an architectural counterpart in the motif of the banister or handrail, which Muñoz has used on a number of occasions, variously reconfiguring and undermining its consolatory and supplementary character. Their contraries are the artist's hunters, dark silhouetted planar figures trapped in a perpetual if linear trajectory. Also part of this lexicon of protagonists, who might be grouped under Muñoz's memorable phrase "the image of a man [going] nowhere," are those stoic inhabitants in makeshift carriages constructed from shoeboxes, who are also condemned to an unending voyage, one that now takes the form of an unvarying circuit.

6. Adrian Searle, "Waiting for Nothing," *Frieze* 2, vol. 1 (December 1991), p. 25.

7. A key precursor to this sculpture is *Girl and Mirror Ball* (1992), a poignant image of an androgynous figure who seems to strive for consummation through self-reflection, or, alternatively, is blinded by self-contemplation (given the vague modeling of the eyes).

8. In his influential study, *Le Moi-Peau* (The Skin-Ego), 1984, Didier Anzieu observes that in the period before the infant's visual field stabilizes, the child is immersed in a sonorous envelope of noises and voices, within which its own voice is both emitted and heard as a kind of "acoustic mirror." Here, Anzieu suggests, the beginning of subjectivity takes place, with the baby's cry signaling the onset of self-recognition and recognition by others, and, in this way, setting in motion the processes of communication and individuation. Thus the infant locates itself in the world first in terms of sound—above all, in relation to the mother's voice and its association with the pleasures of nourishment—well before the moment of self-recognition proposed by Jacques Lacan. Muñoz's figure seems to be attempting a recreation of this primal state of well being, confirming the auditory over the visual. See Christopher Phillips, "From Narcissism to Echo: The Voice as Metaphor and Material in Recent Art," in *Voices* (Rotterdam: Witte de With, 1998), p. 16. Sound, or its absence, have long been a constant thematic in Muñoz's art and warrant a separate study.

9. See Victor I. Stoichita, *A Short History of the Shadow* (London: Reaktion, 1997), p. 221.

10. Promising disembodiment, the substanceless reflection, like the shadow, was often deemed fatal, Marina Warner argues, evidencing Medusa, alongside Narcissus: "To fall in love with one's own image is to lose that identity which is created in separation, in reciprocal interchange with others, in the difference of individuation—in this sense, at least, it entails death to the soul. . . . But the play between self-knowledge and self-image gives the mirror a role in identity, long before Lacan named the Mirror Stage," she contends, while reminding that, "All over Europe, fears about mortality are still attached to images in water or other reflecting surfaces . . . mirrors were—and still are—turned to the wall after a death and window panes draped in mourning cloths because, first, the soul of the deceased might be trapped in the image and become unable to depart in peace; and, second, the survivors should not see themselves reflected so soon after a death because this too can capture other souls." (Marina Warner, "Stolen Shadows, Lost Souls: Body and Soul in Photography," *Raritan* [Fall 1995], pp. 42–43.)

11. The (silently) speaking statue, a recurrent image in Muñoz's oeuvre in the later nineties, has an extensive lineage. According to Kenneth Gross, it is endemic not only to many past cultures but to our most primitive dreams and fantasies. By its very animation, the "living" sculpture raises the question of what is lost or gained, transgressed or restored, by abandoning stillness and speechlessness. Irrespective of whether it is through human subterfuge or through demonic illusion, the figure that gains a voice in myths and legends is traditionally the subject of demonic encounter. See Kenneth Gross, *The Dream of the Moving Statue* (Ithaca: Cornell University Press, 1992).

12. Walter Benjamin quoted in Susan Buck-Morss, "The Flaneur, the Sandwichman, and the Whore: The Politics of Loitering," *New German Critique*, no. 39 (Fall 1986), p. 128. I am deeply indebted to this essay for my reading of Baudelaire and Benjamin.

13. Mention should also be made of the *esperpento*: A literary genre introduced in the 1920s by Spanish playwright, novelist, and poet Ramon María del Valle-Inclán, it is distinguished by the use of stylized portrayals of physically distorted characters to be performed by puppets, whose purpose was to bring out the comic aspects of tragic situations. Muñoz describes himself as a storyteller, a description well borne out in numerous published texts, as well as radio works. Among his memorable tales, some involve sleight-of-hand, others faux-anthropological research. In addition, in 1993 he illustrated Joseph Conrad's short story "An Outpost of Progress."

14. John Berger, *And Our Faces, My Heart, Brief as Photos* (New York: Pantheon, 1984), pp. 67.

15. Muñoz, a conversation with James Lingwood, p. 158.

16. Berger, p. 55.

17. Muñoz, quoted in *Juan Muñoz: Segment*, p. 27.

29

18. Giuliana Bruno draws a sustained analogy between the spectatorial modes of flanerie and the cinema. See Giuliana Bruno, "Streetwalking Around Plato's Cave," *October*, no. 60 (Spring 1992), pp. 111–129. See also Walter Benjamin *Das Passagenwerk*, vol. 5, *Gesammelte Schriften*, ed. Rolf Tiedemann (Frankfurt am Main: Suhrkamp 1982), and "The Flaneur," in *Charles Baudelaire: A Lyric Poet in the Era of High Capitalism* (London: Verso, 1983).

19. From Goya's late grotesque paintings and graphic works to Seurat's silent and still Conté crayon drawings, from film noir to contemporary pop Gothic, Muñoz's visual debts and homages are as broad and deep in range as formerly, if somewhat different in direction. He shares an obsessive engagement with the double, the self-same, the clone, and the facsimile with a number of his contemporaries, from Roni Horn and William Kentridge to Tony Oursler, Douglas Gordon, and Vibeke Tandberg, who all draw on both its ultracontemporary and traditional and legendary manifestations in heterogeneous ways.

20. Before finalizing the exhibition, Muñoz explored an alternative, removing the mirror and dramatically lighting the lone figure placed close to the wall with a low harsh light so that its shadow loomed diabolically in front of itself, seeming to transfix it with fear.

21. Anthony Vidler, *The Architectural Uncanny: Essays in the Modern Unhomely* (Cambridge, Mass.: MIT Press, 1992), p. xiii.

22. Marina Warner, *No Go The Bogeyman: Scaring, Lulling, and Making Mock* (New York: Farrar, Straus, and Giroux, 1998), p. 4.

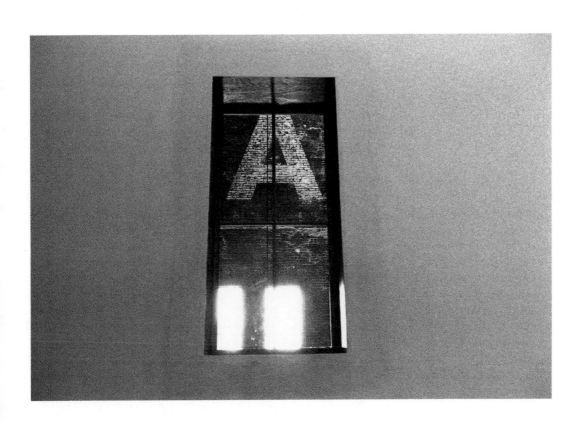

Streetwise

Site Santa Fe

June 6 through August 2, 1998

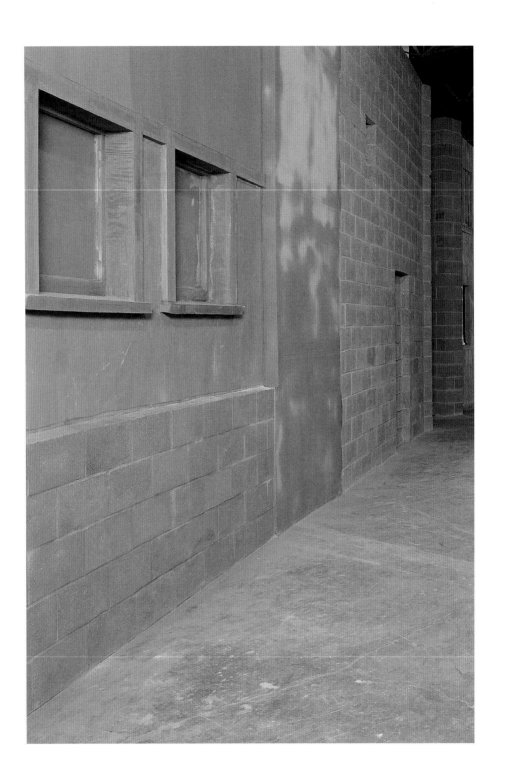

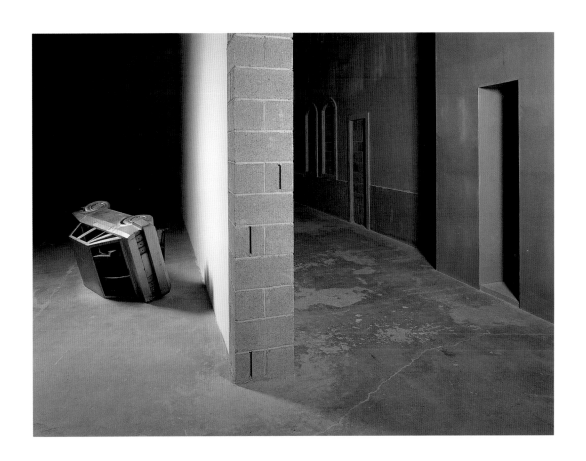

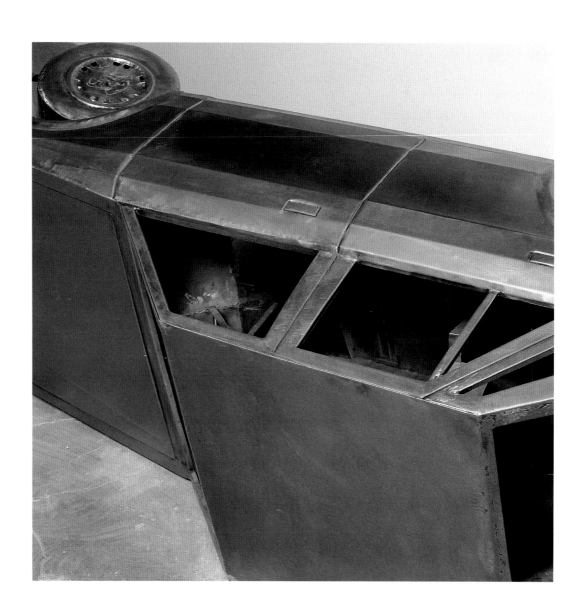

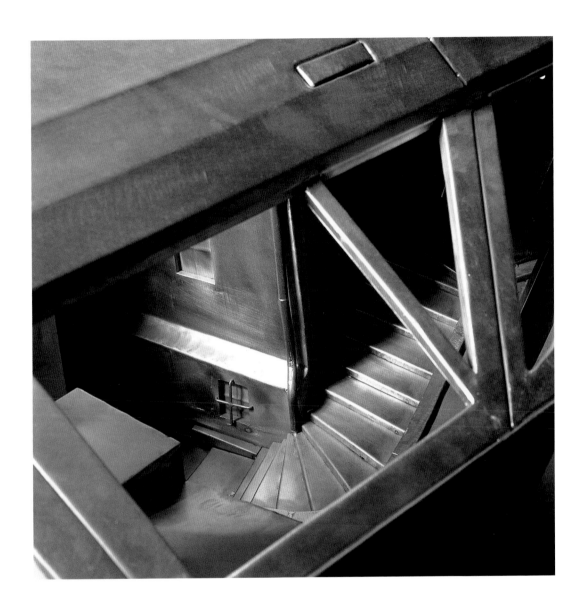

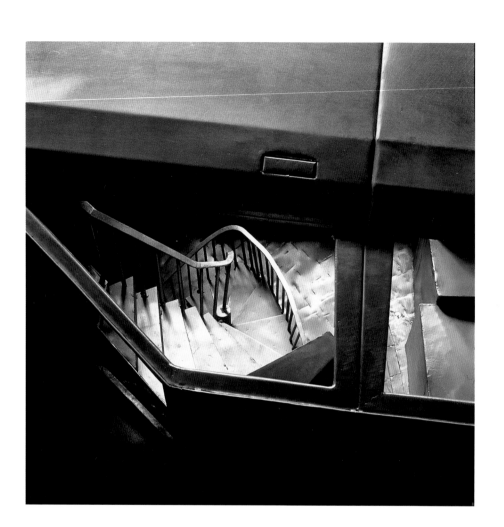

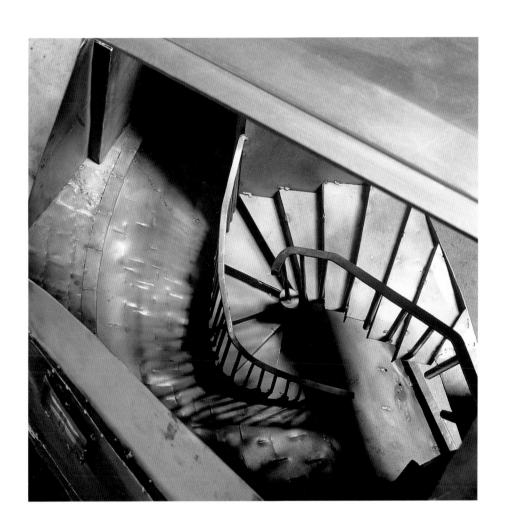

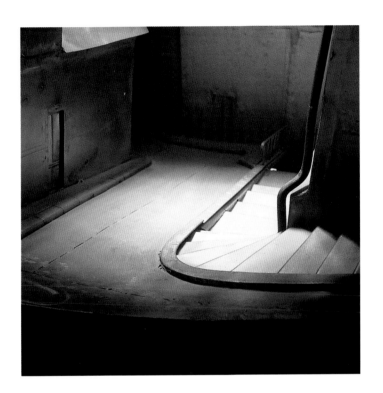

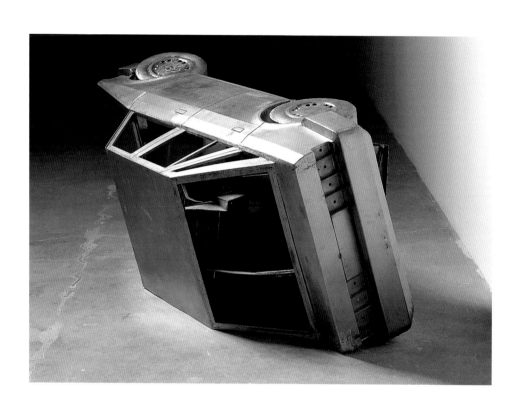

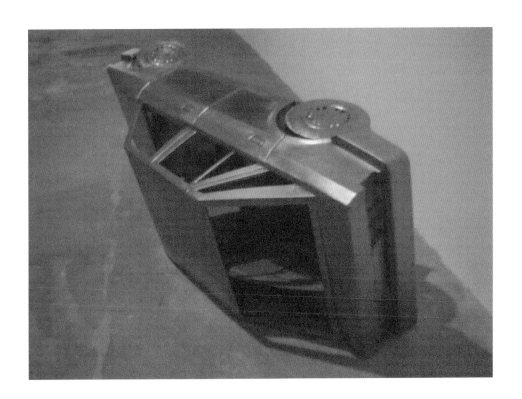

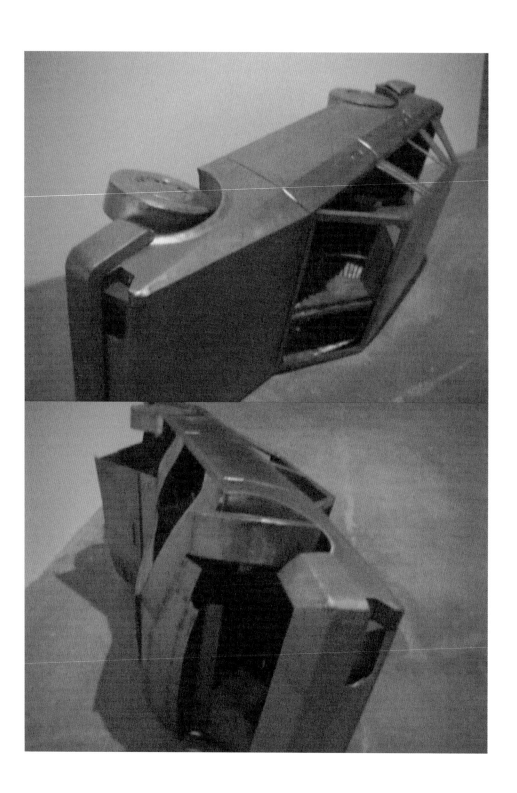

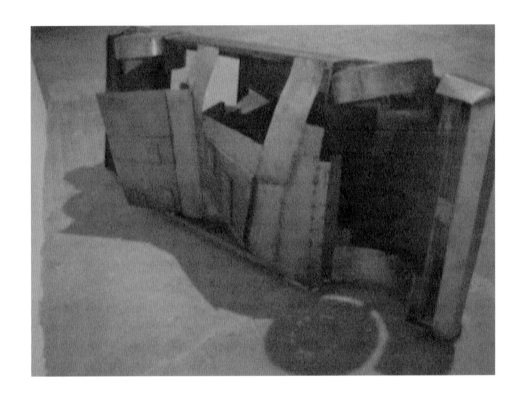

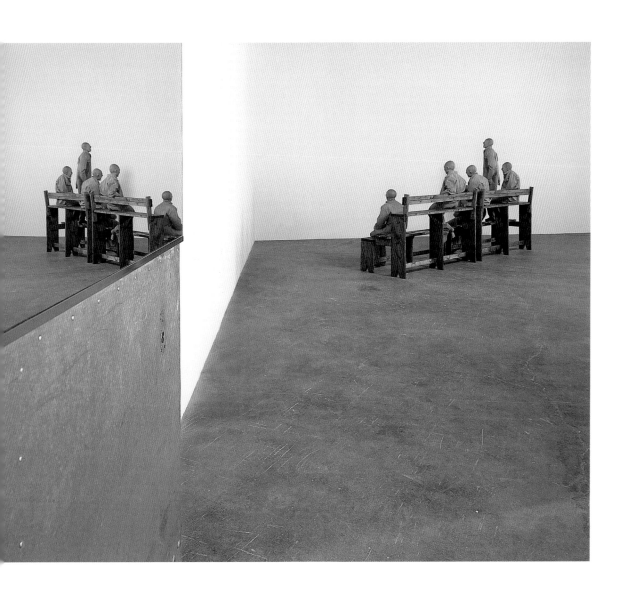

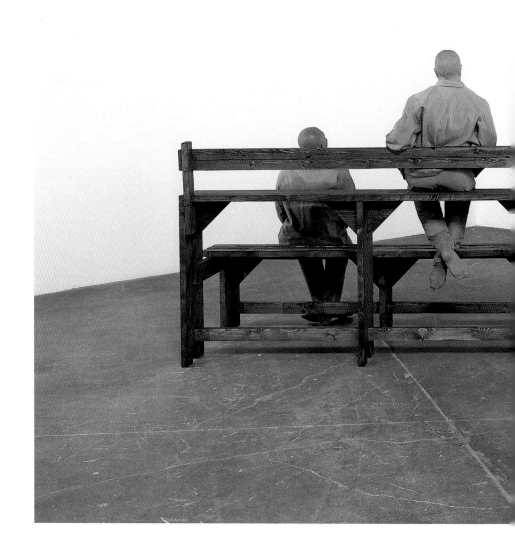

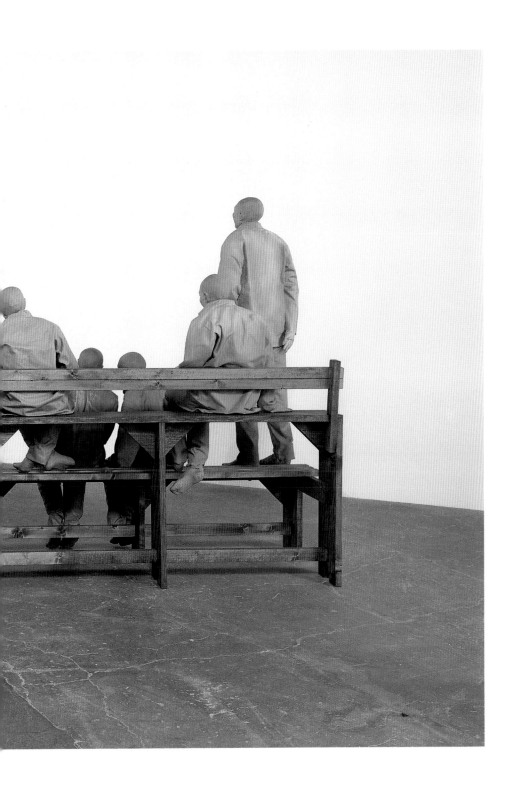

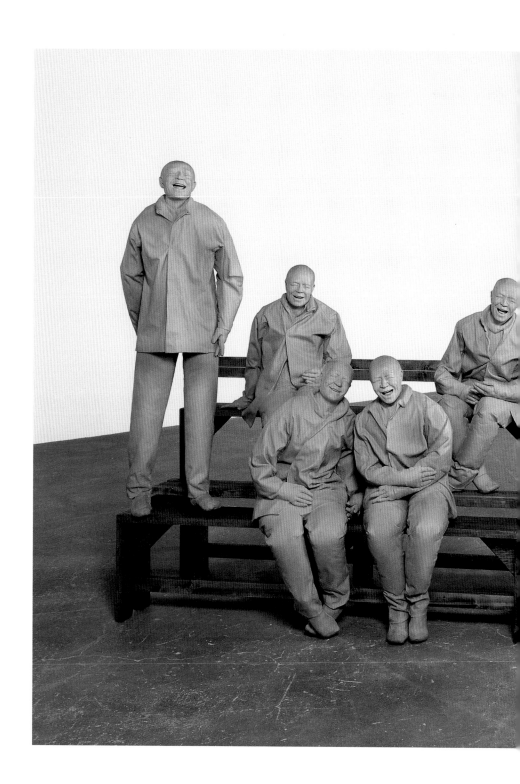

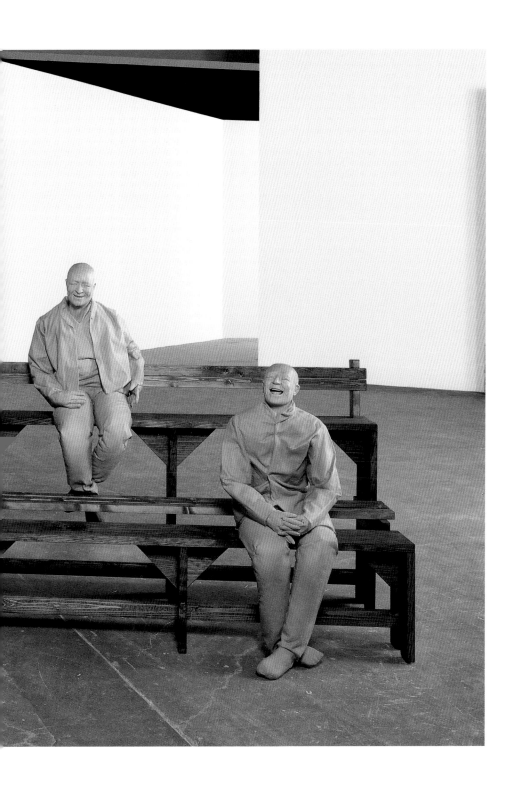

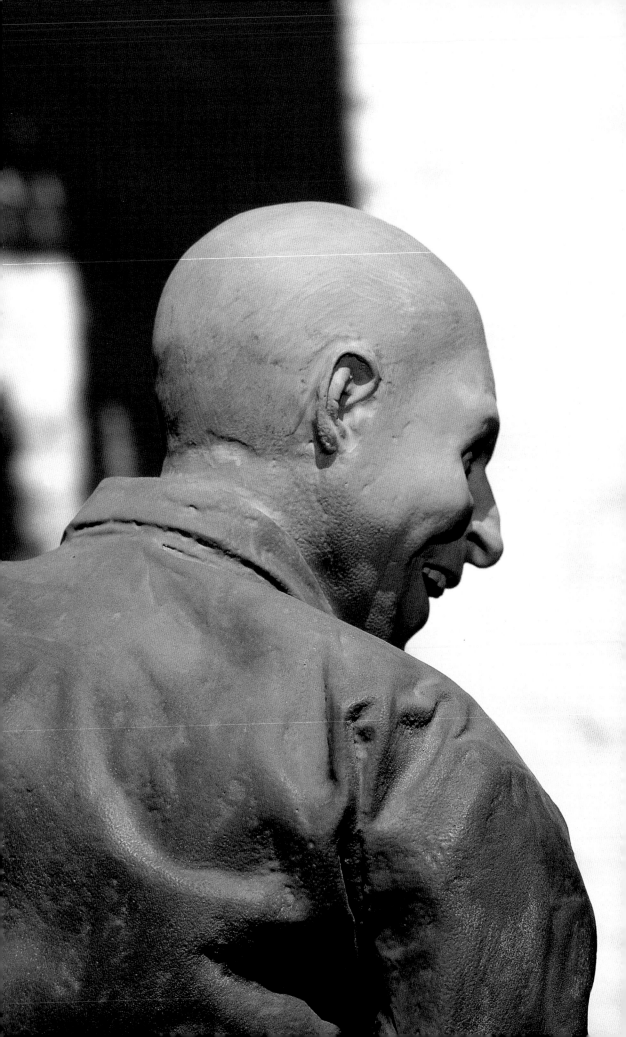

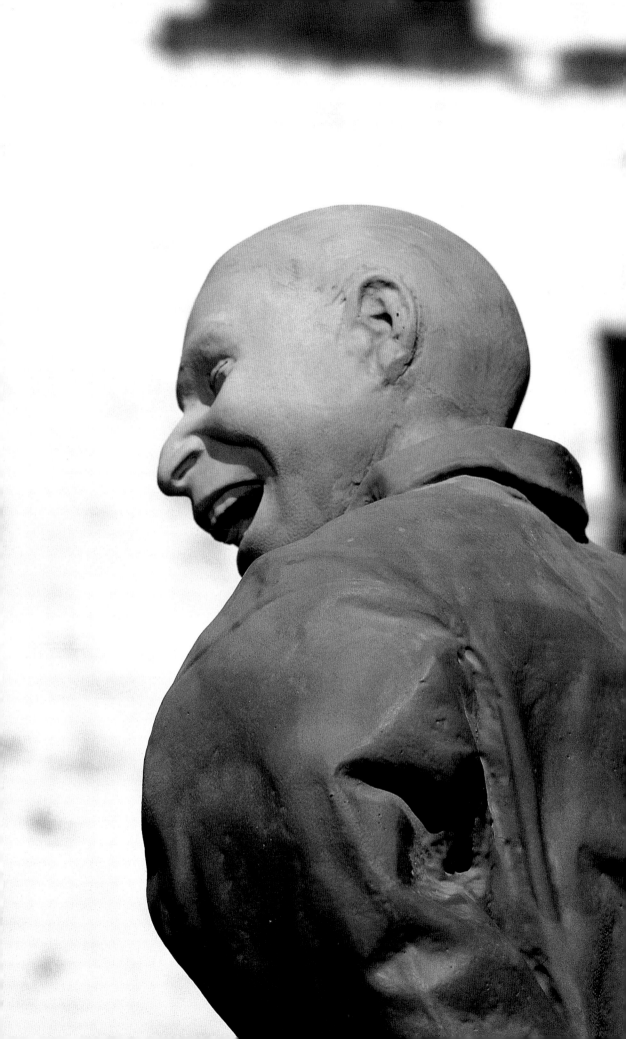

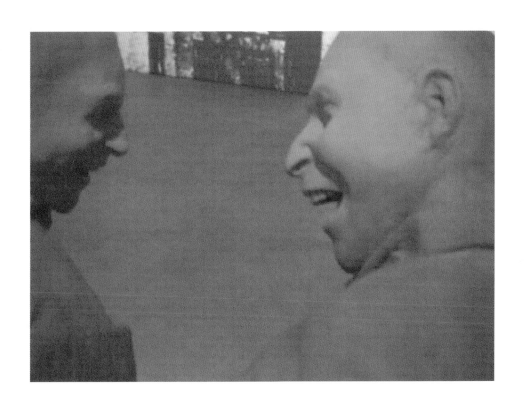

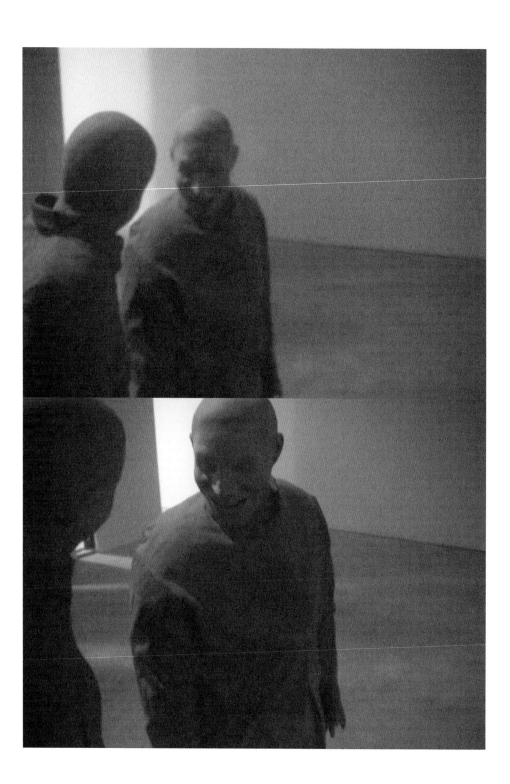

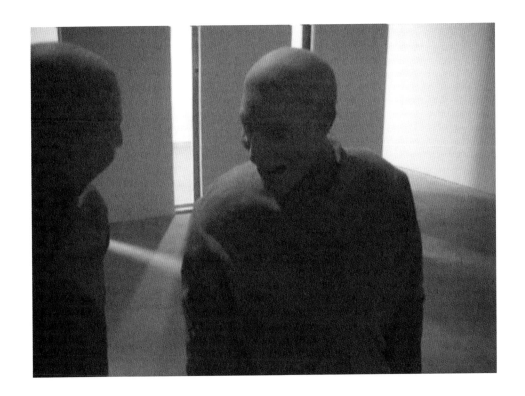

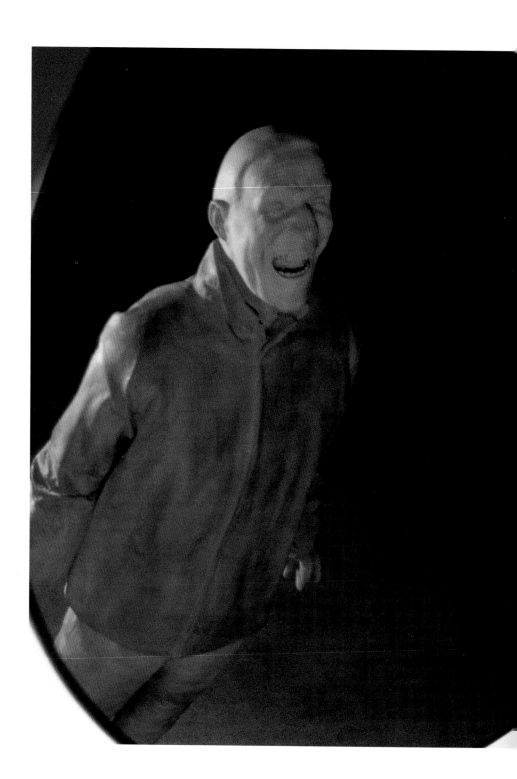

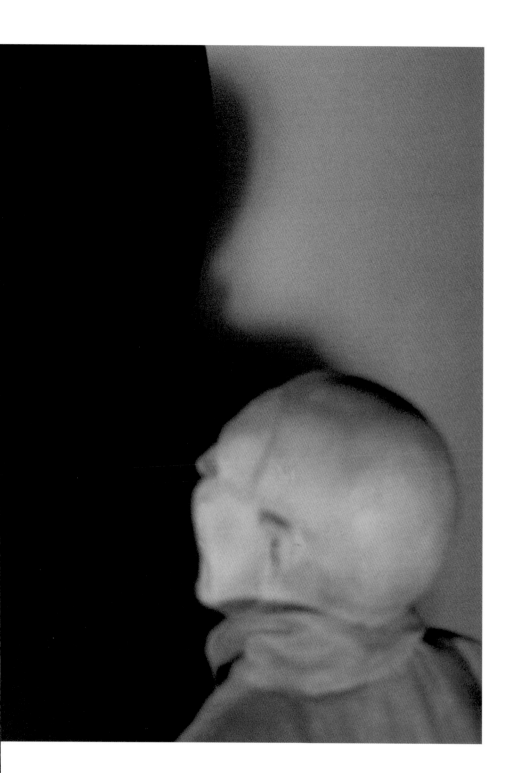

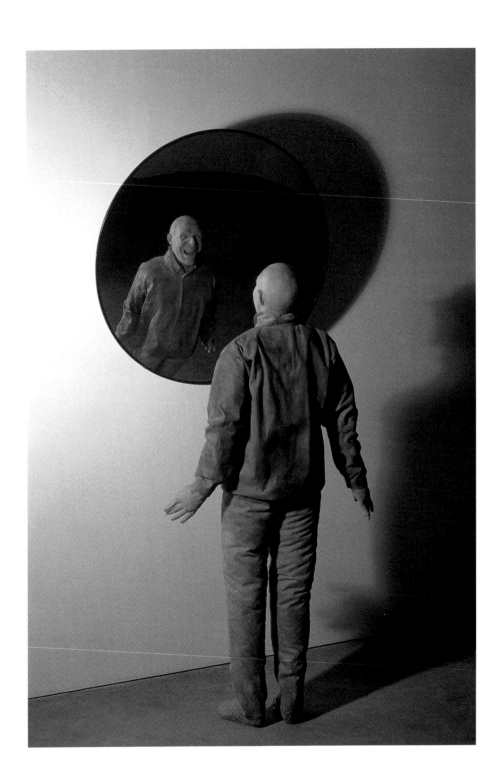

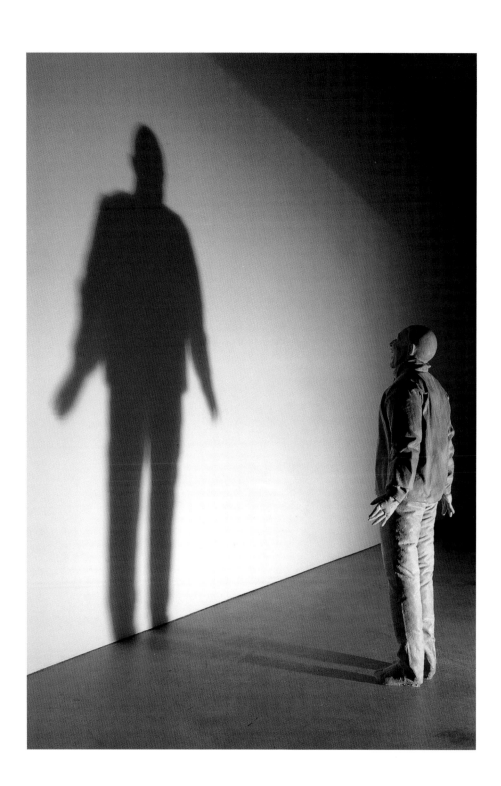

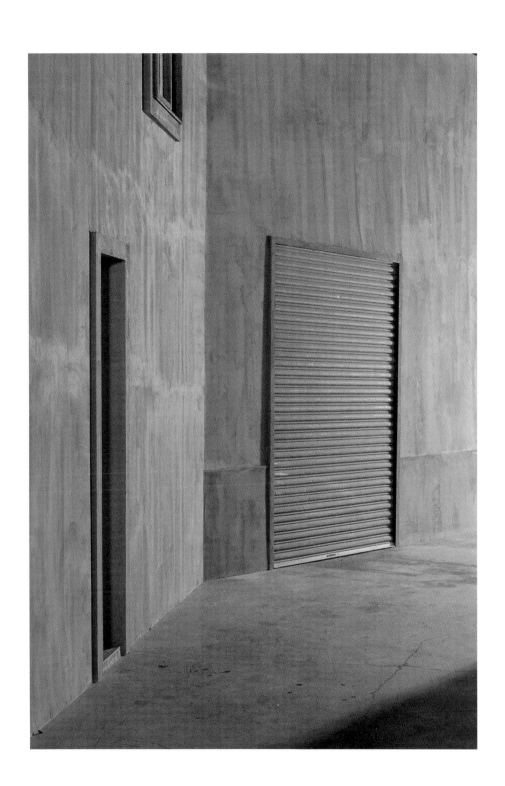

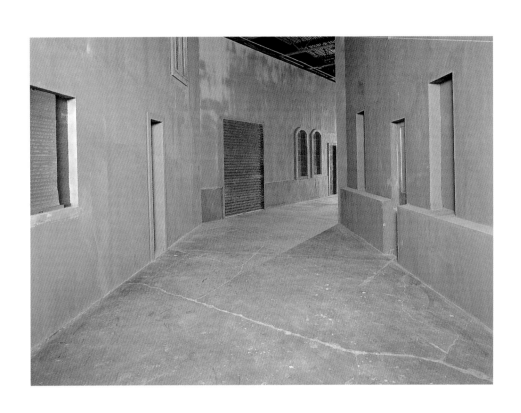

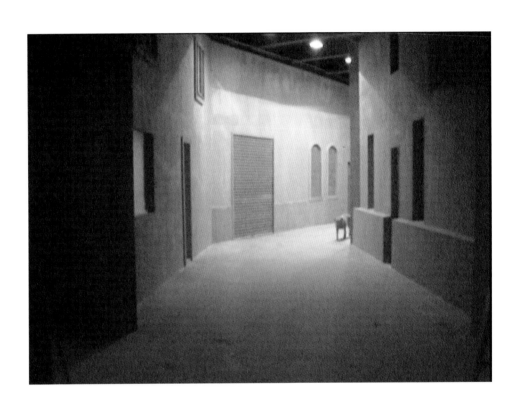

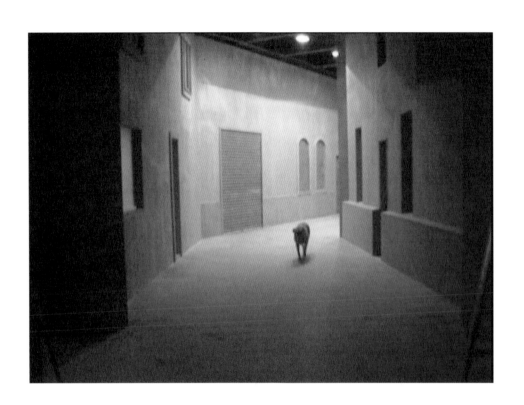

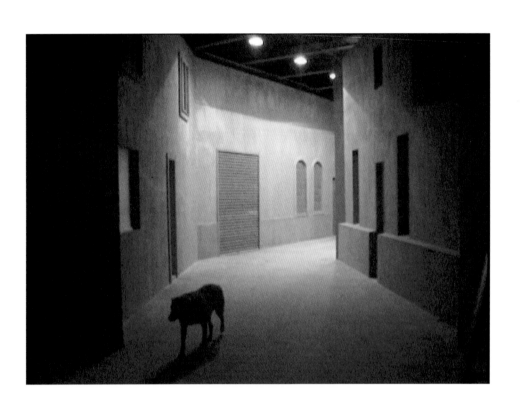

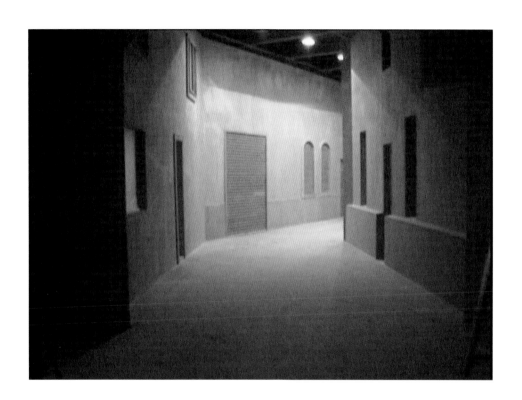

Biography

1953
Born in Madrid, Spain, June 17
1976–1977
Central School of Art and Design, London
1979–1980
Croydon College of Design and Technology, London
1982
Pratt School of Art and Design, New York

Lives and works in Madrid

ONE-PERSON EXHIBITIONS

1999
Marian Goodman Gallery, New York
1998
"Streetwise," Site Santa Fe
1997
"Mobiliario," Marco Noire Contemporary Art,
San Sebastiano Po, Turin
"Directions," Hirshhorn Museum and Sculpture
Garden, Smithsonian Institute, Washington D.C.
"Monologe und Dialoge," Museum für
Gegenwartskunst, Zürich
Galleria Continua, San Gimignano
1996
Galerie Jean Bernier, Athens
"Silence Please: Stories after the Works of Juan
Muñoz," Irish Museum of Modern Art, Dublin
"A Place Called Abroad," Dia Center for the Arts,
New York
"Monólogos y diálogos," Palacio de Velázquez, Museo
Nacional Centro de Arte Reina Sofía, Madrid
1995
"New Work from New Mexico," Laura Carpenter
Fine Art, Sante Fe
Centro Galego de Arte Contemporánea, Santiago de
Compostela
Kunstverein Hamburg
"A Portrait of a Turkish Man Drawing," Isabella
Stuart Gardner Museum, Boston
1994
Carré d'Art, Musée d'art contemporain, Nîmes
Irish Museum of Modern Art, Dublin
1993
Galerie Konrad Fischer, Düsseldorf
Lisson Gallery, London
Galerie Jean Bernier, Athens
Marian Goodman Gallery, New York

1992
"Drawings and Prints," Frith Street Gallery, London
"Conversacíones," Centro del Carme, Instituto
Valenciano de Arte Moderno, Valencia
1991
"Sculpturen, installaties en tekeningen," Stedelijk
Van Abbemuseum, Eindhoven
Marian Goodman Gallery, New York
Galerie Konrad Fischer, Düsseldorf
Galerie Ghislaine Hussenot, Paris
"Arbeiten von 1988–1990," Museum Haus Lange,
Krefeld
1990
"Segment," The Renaissance Society at the
University of Chicago and Centre d'art
contemporain, Geneva
Galerie Jean Bernier, Athens
Arnolfini Gallery, Bristol
1989
Galería Marga Paz, Madrid
Galerie Joost Declercq, Ghent
Lisson Gallery, London
1988
Galerie Jean Bernier, Athens
Galerie Konrad Fischer, Düsseldorf
Galería Còmicos, Lisbon
Galerie Ghislaine Hussenot, Paris
1987
Galerie Roger Pailhas, Marseille
"Sculpture de 1985 à 1987," Capc Musée d'art
contemporain, Bordeaux
Galería Marga Paz, Madrid
Lisson Gallery, London
"Estudos para a descricao de um lugar," Galería
Còmicos, Lisbon
1986
Galerie Joost Declercq, Ghent
Galería Marga Paz, Madrid
1985
Galería Còmicos, Lisbon
1984
"Ultimos trabajos," Galería Fernando Vijande,
Madrid

SELECTED GROUP EXHIBITONS

1999
6th Istanbul Biennial
"Trace," Liverpool Biennial of Contemporary Art

1998
"Wounds: Between Democracy and Redemption in Contemporary Art," Moderna Museet, Stockholm
1997
47th Bienale di Venezia
1996
"Cityscape," Deste Foundation, Athens, in conjunction with the Museum of Modern Art, Copenhagen
1995
"Everything That's Interesting is New," Deste Foundation, Athens
"Trust," Tramway, Glasgow
1994
"Même si c'est la nuit," Capc Musée d'art contemporain, Bordeaux
"Weltmoral: Moralvorstellungen in der Kunst heute," Kunsthalle, Basel
1993
"Sonsbeek '93," Arnheim
"The Boundary Rider," 9th Biennale of Sydney
Documenta 9, Kassel
"Doubletake: Collective Memory and Current Art," Hayward Gallery, London, Kunsthalle, Vienna
1991
"Carnegie International 1991," Carnegie Museum of Art, Pittsburgh
"Metropolis," Martin-Gropius-Bau, Berlin
"Trans/Mission," Rooseum, Malmö
1990
"Possible Worlds: Sculpture from Europe," Institute of Contemporary Arts and Serpentine Gallery, London
"OBJECTives: The New Sculpture," Newport Harbor Art Musuem, Newport Beach
"Weitersehen," Museum Haus Lange and Museum Haus Esters, Krefeld
"The Readymade Boomerang: Certain Relations in 20th Century Art," 8th Biennale of Sydney
"Meeting Place: Robert Gober, Liz Magor, Juan Muñoz," York University, Toronto
1989
"Magiciens de la terre," Musée national d'art moderne, Centre Georges Pompidou, Paris
"Psychological Abstraction," Deste Foundation, Athens
"Theatergarden bestiarium. The Garden as Theater and Museum," PS1, New York
1986
"Chambres d'amis," Museum Van Hedendaagse Kunst, Ghent
"Aperto '86," 42nd Bienale di Venezia

"Ateliers internationaix de Pays de la Loire," Fondation nationale des arts graphiques et plastiques, Abbaye de Fontevraud
"1981–1986. Pintores y escultores españoles," Fundación Caja de Pensiones, Madrid
1985
Stedelijk Van Abbemuseum, Eindhoven
1983
"La imagen del animal. Arte prehistórico, arte contemporáneo," Caja de Ahorros, Madrid, and La Caixa, Barcelona

Bibliography

TEXTS BY THE ARTIST

"The Prompter." *Juan Muñoz: Monologues and Dialogues*. Madrid: Museo Nacional Centro de Arte Reina Sofía, 1996.
"The Face of Pirandello." *Juan Muñoz: Monologues and Dialogues*. Madrid: Museo Nacional Centro de Arte Reina Sofía, 1996.
"Atardecer." *Medardo Rosso*. Santiago de Compostella: Centro Gallego de Arte Contemporáneo, 1996.
"Otto Kurz o la imagen prohibida." *Juliao Sarmento*. Porto: Casa Serralves and Lisbon: Gulbenkian Foundation, 1992–1993.
"Auf einem Platz." (On a Square), *Weitersehen (1980–1990)*. Krefeld: Museum Haus Lange and Haus Esters, 1991.
"A Stone." *Trans/Mission*. Malmö: Rooseum, 1991.
"The Dancing Sailor." *Carnegie International 1991*. Pittsburgh: Carnegie Museum of Art, 1991.
Juan Muñoz: Segment. Geneva: Centre d'art contemporain and The Renaissance Society at the University of Chicago, 1990.
"Spazio Umano: A Text by Juan Muñoz." *International Magazinebook of Art and Literature* (March 1989).
"Tres imágenes o cuatro." *Art Today*. Tokyo: Museum of Modern Art, Takamawa, Kamizawa, 1989.
"The Prompter (1988)." *Theatergarden bestiarium*. New York: The Institute of Contemporary Art, PS1, 1989.
"Un objeto metálico." *Arti et Amicitae*. Amsterdam (May 1988).
"La imagen prohibida o el juego de la rayuela." *Conde*. 1987.

"Nada es tan opaco como un espejo." *Sur Exprés*, no. 1 (April–May 1987).

"De la luminosa opacidad de los signos." *Figura*, no. 6 (Fall 1986).

"Desde . . . a . . ." *Figura*, no. 5 (Spring 1986).

"El hijo mayor de Laocoonte." *Chema Cobo*. Bern: Kunstmuseum Bern, 1986.

"Richard Long: De la precisión en las distancias." *Richard Long*. Madrid: Palacio de Cristal, 1986.

"Un hombre subido a una farola." *Escultura inglesa entre el objeto y la imagen*. Madrid: Palacio de Velázquez, 1986.

"La palabra como escultura." *Figura*, no. 4 (Winter 1985).

"The Best Sculpture is a Toy House." *Domus*, no. 659 (March 1985).

"Los primeros–Los últimos." *La imagen del animal. Arte prehistórica, arte contempráneo*. Madrid: Caja de Ahorros and La Caixa de Barcelona, 1983–1984.

"Correspondencias." *5 Arquitectos, 5 escultores*. Madrid: Palacio de las Alhajas, 1983.

INTERVIEWS

Jan Debbaut. "Fragments of a Conversation (Lisbon, May 1984–Madrid, October 1984)." *Juan Muñoz, Últimos trabajos*. Madrid: Galeriá Fernando Vijande, 1984.

Jean-Marc Poinsot. "A Conversation between Juan Muñoz and Jean-Marc Poinsot." *Juan Muñoz: Sculptures de 1985 à 1987*. Bordeaux: Capc Musée d'art contemporain, 1987.

Iwona Blazwick, James Lingwood, and Andrea Schlieker. "A Conversation with Juan Muñoz." *Possible Worlds: Sculpture from Europe*. London: Institute of Contemporary Arts, 1990.

Maya Aguriano. "Juan Muñoz." *Zehar*, no. 6 (September–October 1990).

James Lingwood. "A Conversation: New York, January 22, 1995." *Parkett*, no. 43 (March 1995).

James Lingwood. "A Conversation, September 1996 (I and II)." *Juan Muñoz: Monologe und Dialoge/Juan Muñoz: monólogos y diálogos*. Zürich: Museum für Gegenwartskunst, 1997, Madrid: Museo Nacional Centro de Arte Reina Sofía, 1996.

SELECTED CATALOGUES

Juan Muñoz: Monologe und Dialoge/Juan Muñoz: monólogos y diálogos. Zürich: Museum für Gegenwartskunst, 1997, Madrid: Museo Nacional Centro de Arte Reina Sofía, 1996. Texts by James Lingwood and Juan Muñoz. Interviews by James Lingwood, Iwona Blazwick, and Andrea Schlieker.

Silence Please: Stories After the Works of Juan Muñoz. Dublin: The Irish Museum of Modern Art and Zürich: Scalo, 1996. Texts by John Berger, Dave Hickey, Lynne Tillman, William Forsythe, Vik Muniz, Luc Sante, et al.

Juan Muñoz: Portrait of a Turkish Man Drawing. Boston: Isabella Stewart Gardner Museum, 1995. Text by Jill S. Medvedow.

"Juan Muñoz." *Parkett*, no. 43 (1995). Texts by Lynne Cooke, Alexandre Melo, and Gavin Bryars.

Juan Muñoz. Nîmes: Carré d'art contemporain, 1994. Text by Guy Tosatto.

Juan Muñoz: Conversaciones. Valencia: Centre del Carme, IVAM, 1992. Texts by Juan Muñoz.

Doubletake: Collective Memory and Current Art. London: Hayward Gallery, 1992. Texts by Lynne Cooke, Bice Curiger, and Greg Hilty.

Juan Muñoz: Arbeiten 1988–1990. Krefeld: Museum Haus Lange, 1991.

Carnegie International 1991. Pittsburgh: The Carnegie Museum of Art, 1991. Texts by Lynne Cooke and Mark Francis.

Trans/Mission: Art in Intercultural Limbo. Malmö: Rooseum, 1991. Ed. Lars Nittve. Text by Dick Hebdige.

Sculpturen, installaties en tekeningen. Eindhoven: Stedelijk Van Abbemuseum, 1990.

Weitersehen. Krefeld: Museum Haus Ester and Museum Haus Lange, 1990. Text by Julien Heynen.

Meeting Place: Robert Gober, Liz Magor, Juan Muñoz. Toronto: York University, 1990. Text by Gregory Salzman.

OBJECTives: The New Sculpture. Newport Beach, California: Newport Habor Art Museum, 1990. Texts by Lucinda Barnes, Kenneth Baker, and Paul Schimmel.

Magiciens de la terre. Paris: Musée national d'art moderne, Centre Georges Pompidou, 1989. Text by Jean-Hubert Martin, et al.

Juan Muñoz. Abbaye de Fontevraud: FRAC des Pays de la Loire, 1987. Text by José-Luis Brea.

La imagen del animal. Arte prehistórico, arte contemporáneo. Madrid: Caja de Ahorros and Barcelona: La Caixa, 1983.

Major funding for *A Place Called Abroad* and *Streetwise* and this publication has been received from the Lannan Foundation; the Burnett Foundation; Plácido Arango; Nancy and Dr. Robert C. Magoon; the National Endowment for the Arts, Washington, D.C.; the Spanish Ministry of Culture; and the members of the Dia Art Council.

Edited by Karen Kelly
Editorial Assistant: Bettina Funcke

Designed by Filiep Tacq, Leopold en Zonen

Printed in Spain by Ediciones El Viso, Madrid

The artist extends his gratitude to the following people:
Adrian Searle, Mimi Muñoz, and Ruben Polanco

Photo credits:
Cathy Carver (Dia); Cuauhtli Gutierrez (text photos);
Michael Goodman (Site Santa Fe); Attilio Maranzano (Site Santa Fe);
Cristina Iglesias (video images).

Quotes on exile by Breyten Breytenbach, William H. Gass, Eva Hoffman, and Edward Said are reprinted from: *Altogether Elsewhere: Writers on Exile*. Ed. Marc Robinson. Boston: Faber and Faber, 1994.

ISBN 0-944521-39-8

Distributed by
D.A.P.
155 Sixth Avenue
New York, New York 10013
(800) 338-BOOK

What is it really like to be exercising the "dur métier de l'exil," to be "climbing up and down other people's staircases," to be "changing countries more often than changing your shoes . . .

It is, when you are a writer, to be living *elsewhere* (*ailleurs*), to be writing *differently* (*autrement*). You live in an acquired linguistic zone like going dressed in the clothes of the husband of your mistress. . . . You live and you write in terms of absence, of absent time (or in terms of a questioned present time). Not an imagined or remembered existence: more an absent present. A state of instant reminiscence. . . . Your relationship with the world around you is that of the foreign observer. Or you turn in upon yourself, turn yourself over, observe the albino insects scurrying away from the light. And you taste a distaste, bloated as the tongue in its orifice of saying.

. . . you never really relax. You never completely "belong." And yet—your situation is probably a blessing in disguise. Freedom, because that is where you're at, is a nasty taskmaster. You have so much more to learn. . . . For better or for worse you are an outsider. You may be a mutant, for all you know. . . . If so you are privileged.

—*Breyten Breytenbach*